SECRE
GREENWICH

David C. Ramzan

AMBERLEY

First published 2017

Amberley Publishing
The Hill, Stroud
Gloucestershire, GL5 4EP

www.amberley-books.com

Copyright © David C. Ramzan, 2017

The right of David C. Ramzan to be identified as the
Author of this work has been asserted in accordance
with the Copyrights, Designs and Patents Act 1988.

ISBN 978 1 4456 7510 7 (print)
ISBN 978 1 4456 7511 4 (ebook)

British Library Cataloguing in Publication Data.
A catalogue record for this book is available from the
British Library.

Origination by Amberley Publishing.
Printed in Great Britain.

Contents

River Through the Ages, a mosaic by Philippa Threfall located off Woolwich Road.

Introduction

I clearly remember as a child the incredible stories told of ancient pagan warriors, murderous Viking raiders, mighty kings and queens, chivalrous knights, courageous heroes, devious villains, intrepid sailing ships, elegant palaces and mysterious underground tunnels and caverns associated with the place of my birth. These extraordinary tales could well have come straight from the pages of adventure novels, except these stories were factual accounts of the long and ancient history of Greenwich. Established as a permanent riverside fishing settlement on the south bank of the River Thames during the Saxon migration into Britain, Greenwich, or Gronewic, as recorded in the Saxon charter of AD 918, meaning the 'green settlement', became a place of pilgrimage after Ælfheah, the Archbishop of Canterbury, also known as Alfege, was killed by pagan Danish warriors and a Christian place of worship was established where the Anglo-Saxon was mortally wounded. The settlement evolved into an important strategic military and industrial town where fortified strongholds and grand royal places were constructed, celebrated warships and enterprising merchant vessels were built and launched, splendid suits of armour and new types of munitions were made, and innovative advancements in engineering and telecommunications took place. There is evidence of early Roman activity preceding Saxon occupation, where a religious shrine was discovered at Greenwich Park, east of some eighty mounds of Bronze Age origin used by Saxons as a burial ground.

Boasting the longest stretch of Thames river frontage compared to any other London borough, and steeped in maritime history, heritage and tradition, Greenwich was the birthplace of Henry VIII and his two daughters Mary and Elizabeth, all born at the Palace of Placentia. When Francis Drake returned from his voyage of discovery on the *Golden Hind*, the first Englishman to circumnavigate the globe, the galleon returned loaded with exotic goods and plundered Spanish treasure estimated to be worth almost half a billion pounds today. The privateer became a national hero and was knighted by Elizabeth aboard his ship moored off Deptford Creek. The queen made a declaration that the *Golden Hind* should be preserved, and so the galleon became the first of many Greenwich tourist attractions. The valiant ship and the grand palace fell into disrepair during the English Civil War; the remains of the *Golden Hind* were broken up and the remnants of the Tudor palace pulled down when a much grander royal place of residence was built after the Restoration. By the reign of William and Mary, only one wing had been completed, and instead of a royal palace a magnificent royal hospital for maritime pensioners was built in its place. Greenwich became central to where eastern and western hemispheres converged along the Prime Meridian Line, dividing the town through its centre into two distinct areas of east and west. Internationally known as the home of world time, clocks around the globe were set to correspond with Greenwich Mean Time.

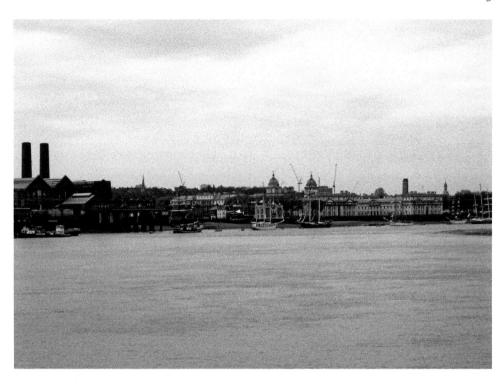

Above: Greenwich Embankment.

Right: Meridian Line, Park Row.

The Board of Longitude commissioned the design of a marine chronometer to accurately plot a vessel's position of longitude from Greenwich, revolutionising navigation for ships sailing uncharted and inhospitable oceans and seas around the world. The body of Vice Admiral Horatio Nelson, commander of the victorious British fleet at the Battle of Trafalgar, was laid in state within the magnificent Painted Hall at Greenwich Hospital after dying when shot aboard his flagship HMS *Victory*. During the Second World War, through the Luftwaffe's strategically targeted air strikes on many important riverside industries, various historic places of Greenwich also suffered severe bomb damage. A majority of buildings left in ruin were then pulled down, while others that should have been saved for future generations were demolished to make way for modern residential and industrial developments. Those most celebrated places to have survived, including the National Maritime Museum, Royal Observatory and Royal Naval College, became the most popular attractions of Greenwich. However, many other fascinating places were associated with the riverside town, some long gone, others hidden away, and several overlooked altogether. Made a World Heritage site in 1997, Elizabeth II then granted royal status to the borough of Greenwich in recognition of the historic links between the Crown and the maritime town.

Greenwich, the Royal Borough.

1. Royal Localities

The first associations between royalty and the settlement of Greenwich came prior to the Norman Conquest of England, when two Anglo-Saxon manors, Old Court and Combe, gifted by Princess Elstrudis, daughter of King Alfred, to the Abbey of St Peter at Ghent, were combined to create the manor of Greenwich. Bishop Odo of Bayeux, half-brother of William the Conqueror and second in power to the king, was appointed Earl of Kent and tenant in chief of the manor of Greenwich. The Domesday book recorded Greenwich as consisting of thirty-four households, twenty-four villagers, four smallholders and one cottager, the settlement considered quite large for its time. When Odo fell out of favour with the king for attempting to defraud the Crown, his lands, including the manors of Greenwich and Eltham, were seized in 1082. Under the ownership of Anthony Bek, Bishop of Durham, the small manor house at Eltham was rebuilt and a defensive wall erected along the surrounding moat. Eltham Manor was presented to the future king of England, Edward II, who granted the manor to his queen, Isabella, after their coronation. Further improvements were made to the fortified manor house and by the early fourteenth century Eltham had become the largest of England's royal palaces. Although Eltham Palace grew in importance as a royal residence, the manor of Greenwich, situated next to the River Thames and easily accessible from London by boat, became favoured over Eltham as a royal abode.

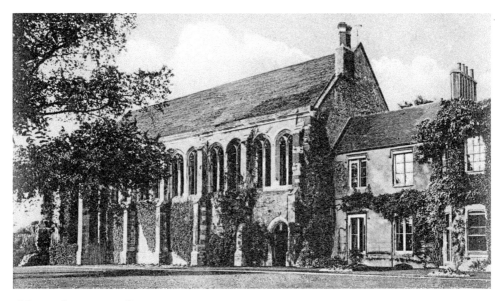

Eltham Palace Great Hall.

Edward II's father, Edward I, made regular visits to Greenwich where in 1217 a grand tournament was held with knights competing in jousting exhibitions and men at arms demonstrated skills in the art of warfare, the festivities closing with a great feast held at the manor farm of Old Court. During the reign of Henry VIII, Old Court, in close proximity to Greenwich Palace, was reputed to have been where the king's mistress Anne Boleyn resided, the house also believed to have been where Henry's only legitimate son, and future king, Edward died aged just fifteen. The ancient and historic building of Old Court, from where the manor of Greenwich was administered on behalf of the priory of St Peter at Ghent, was demolished during the early seventeenth century and a large mansion erected on the site. In 1408 Henry IV wrote his will at Greenwich, and after his death the manor was passed to Thomas Beaufort, Henry's half-brother. Beaufort spent little time at Greenwich, often off campaigning abroad, however, after returning from the French Wars, he spent his last days at Greenwich where he died in 1427. The manor passed to Humphrey, Duke of Gloucester, who enclosed 200 acres of the estate to form a park and erected a fortified tower at the park's highest point, close to where the Royal Observatory stands today. The duke built a magnificent property on the riverfront, known as Bella Court, and established a library of rare scholarly books, the volumes later founding the Bodleian Library at Oxford. Bella Court was seized by Margaret of Anjou after Humphrey had been accused of treason against her husband, the duke's nephew Henry VI, Humphrey dying in captivity under mysterious circumstances. Queen Margaret occupied Bella Court, renaming the royal residence Pleasance, meaning a pleasant place.

Formerly Duke Humphrey Tower, Greenwich Castle.

Improvements made to the palace took five years to complete, the refurbishments including the building of a vestry for the safekeeping of the crown jewels, the installation of a 14-foot-long bay window glazed with stained glass – a rarity during this period – and a pier erected for ease of access to the river. The palace came into the possession of Henry VII after taking the crown from Richard III, who was killed at the Battle of Bosworth, the former king having seized the crown after the unexplained disappearance of his nephews, princes Edward and Richard, the legitimate heirs to the throne. As a boy, Richard spent time at Greenwich and when older attended a tournament at the palace celebrating the marriage of the youngest of his nephews, Richard, Duke of York, only five years old at the time. Henry VII had the older buildings pulled down, replacing them with a much grander structure, built with over 600,000 red bricks made at Greenwich brickworks. The palace, then known as Placentia, included an inner courtyard with royal lodgings overlooking the river, a hall and chapel to the east, and a gallery to the west leading to the house of the Greyfriars, an order of monks established towards the end of Edward IV's reign. Henry, credited for laying down the foundations of England's navy, made Placentia his main royal residence where his youngest son Henry was born. Although Henry VIII held court at both Greenwich and Eltham, the Thameside palace became his favourite residence, where daughters Mary and Elizabeth were born and the king married his first wife, Catherine of Aragon, and later his fourth wife, Anne of Cleves. Henry continued to spend lavishly upon improving the palace at Greenwich, and although Eltham continued to be used as a royal residence, by the seventeenth century the buildings had fallen out of use.

DID YOU KNOW?

The religious order of the Grey Friars of England changed the colour of their habits from London russet to white-grey in 1502 on the insistence of the Friars of Greenwich, their order located at the Palace of Placentia, as the cloth was much cheaper.

Eltham Palace north entrance.

After the Royalists were defeated by the Parliamentarians, in 1651 Eltham Palace was seized and sold by the government to Colonel Nathaniel Rich. The buildings were stripped of materials and sold as salvage, the great hall and a majority of the palace buildings left to fall into decay. After the Restoration, the remains of Eltham Palace were leased by Charles II to Sir John Shaw, a royalist supporter during the Civil War, who built a new manor house, Eltham Lodge, at the site. The remains of the original palace were used as farm buildings up until the early nineteenth century when a villa was built towards the north of the great hall, incorporating the old farmhouse. In 1933 a wealthy member of the Courtauld family, Sir Stephen Courtauld, leased the estate, commissioning the building of a modern residence to complement the repaired and renovated great hall. Eltham Palace, located only 4 miles from Greenwich, is maintained by English Heritage and open to the public throughout the year. Greenwich Palace had grown in importance during Henry VIII's reign, armouries were built close to the palace terrace, the splendid Greenwich suits of armour famed throughout Europe, and a magnificent Banqueting Hall was constructed to impress visiting foreign dignitaries. The palace, its buildings sweeping majestically along the south bank of the Thames, had become the largest and most modern of Tudor royal residences. Extravagant and sumptuous banquets and revelries were held at Greenwich, where, at one of Henry's celebrated Christmas festivities, a masquerade was introduced into England for the first time.

Under the king's instruction, the old Duke Humphrey tower and fortification, known as Greenwich Castle, was enlarged and refurbished. The stronghold is believed to have been used for secret liaisons between Henry and his mistresses while married to Anne Boleyn, mother of Princess Elizabeth. After succeeding Edward VI and then Catholic

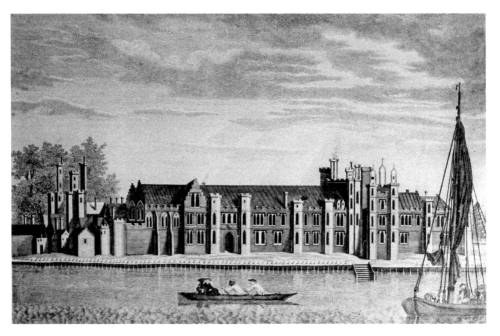

Palace of Placentia.

Mary I to the throne of England, the Palace of Placentia became Elizabeth's main royal residence and principal seat of court after being crowned queen in 1558. During the early period of Elizabeth's reign, many plots were hatched by Catholic conspirators to remove the queen from the throne and replace her with Mary, Queen of Scots, her cousin. In response, Elizabeth held a military review at Greenwich Park as a show of force against her enemies, where 1,400 soldiers performed a mock battle in front of the queen and royal courtiers, some of whom would have been members of the nobility attempting to remove her. When Mary, Queen of Scots, was charged and found guilty of her involvement in an assassination plot against Elizabeth, Parliament compelled the queen to sentence Mary to death. Agonising over the decision for four months, in 1587 Elizabeth reluctantly signed the death warrant of her cousin at Greenwich Palace. In more happier times, Elizabeth regularly celebrated the festival of St George's Day while holding court at Greenwich, the ceremony and feasting lasting for over two days, and it was at Greenwich Palace where Walter Raleigh first met the queen, laying down his cloak over a puddle for Elizabeth to walk upon. Swiftly gaining advancement within the royal court, Raleigh was knighted by Elizabeth at Greenwich in 1585, and appointed captain of the Queen's Guard. Elizabeth was succeeded by James VI of Scotland and I of England, son of Mary, Queen of Scots, the king giving Greenwich Palace and the park grounds to his wife, Anne of Denmark. The queen made improvements to the palace buildings, walled in the park and commissioned the construction of a large impressive apartment, named the House of Delight, located towards the park's north boundary, later becoming known as the Queen's House. During the reign of Charles I, the king spent a considerable amount of time at Greenwich Palace where his wife, Queen Henrietta Maria, oversaw the completion of the Queen's House and its decoration and furnishing; the house was said to have surpassed all others of its kind in England. At the outset of the English Civil War, Charles I fled to Greenwich Palace, his last stronghold in London, before heading north to escape Parliamentarian forces. Greenwich Palace fell into disrepair during the war and while under Parliamentarian control the buildings were used as a factory supplying biscuits to Oliver Cromwell's army campaigning against the Scots, and for housing prisoners of war. After the Restoration, Charles II engaged architect John Web to design a new palace, intending to demolish the derelict buildings when work began. The only section to be completed, however, was the King's House, the palace left incomplete when royal attention turned towards the development of the Royal Dockyards and the Royal Arsenal and Laboratory at the Warren, Woolwich, producing armaments, gunpowder and canons.

Within the armaments site, a military academy was founded for training officers and artillery engineers, the academy gaining royal status in 1760. Outgrowing the premises on the Warren, the academy relocated to an impressive series of Tudor Gothic-style buildings erected during the nineteenth century at Woolwich Common, the listed buildings recently refurbished for incorporation into a large private housing complex. The Royal Artillery Barracks relocated from the Warren during the late eighteenth century to new barracks north of Woolwich Common, the southern frontage, enlarged in the early 1800s, is the longest continuous architectural structure in London. The Warren, the site of an Iron Age settlement, had been used for keeping rabbits on the estate of Tower Place, Old Woolwich, a Tudor mansion built during the mid-sixteenth century for Martin

Woolwich Arsenal Main Guard House.

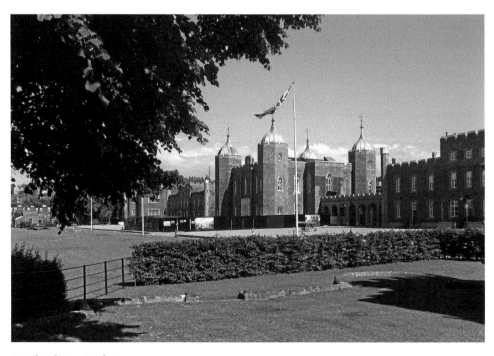

Royal Military Academy.

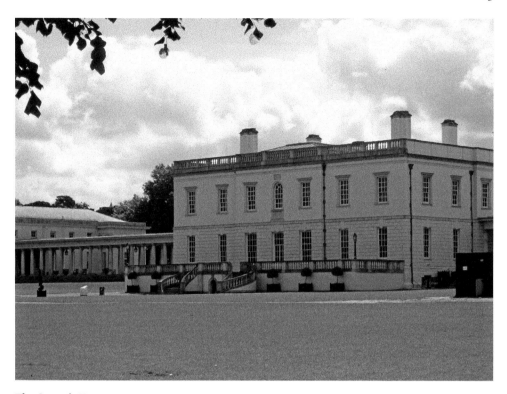

The Queen's House.

Bowes, a wealthy merchant and Lord Mayor of London. Purchased towards the end of the seventeenth century for use by the Board of Ordnance to expand Woolwich Royal Dockyard's manufacture of munitions, the site evolved into the Royal Arsenal armaments works after the Great Gunpowder Barn at Greenwich Palace was relocated to Woolwich before work commenced on building Greenwich Royal Hospital in 1695. Erected on the site of the old Greenwich Palace, Greenwich Royal Hospital – the word hospital during this time meaning a provision of hospitality for those in need – had first been proposed by James II. The king's intention was to create a naval equivalent of Chelsea Hospital for retired and injured soldiers. When the king was exiled to France after the 'Glorious Revolution' of 1688, his daughter Mary continued the project when reigning as joint sovereign with husband William, Prince of Orange.

DID YOU KNOW?
When it became known that Sir Christopher Wren's original plans for Greenwich Hospital would block the riverside view from the Queen's House, Mary II ordered the architect to revise his plans and divide the buildings to provide an avenue leading from the river to the Queen's House.

Sir Christopher Wren, assisted by Nicholas Hawksmoor, gave his architectural services for free when commissioned to design the hospital. Sir John Vanbrugh succeeded Wren as architect for the completion of the magnificent colonnaded buildings, planned to symmetrically complement the existing King's House known as King Charles's Quarter. The new hospital buildings were erected across the foundations of the old palace, only the Tudor crypt surviving demolition. The three new quarters included Queen Anne's Quarter, Queen Mary's Quarter and King William's Quarter. The building famed for its magnificent Painted Hall is one of Europe's most spectacular baroque interiors, created by the eminent artist Sir James Thornhill. The Painted Hall murals portrayed a time when Britain was a dominate global power, with one of the scenes depicting the ascension of William III and Mary II to the throne in 1689. The first pensioners took up residence in 1705, and by the century's end over 2,000 were living at Greenwich Royal Hospital. The Painted Hall, originally planned as the pensioners' dining room, was considered too grand for this purpose, and the pensioners were moved to the vaulted undercroft. The Painted Hall became a visitors' attraction where pensioners organised tours to earn money for the hospital's upkeep. After the body of Admiral Nelson returned from the Battle of Trafalgar preserved in a barrel of brandy, his remains were laid in state at the Painted Hall before being interned at St Paul's Cathedral. The Painted Hall was then transformed into the National Gallery of Naval Art where marine paintings were hung on display until 1936.

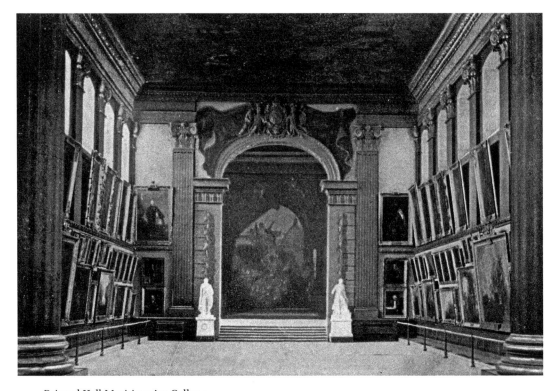

Painted Hall Maritime Art Gallery.

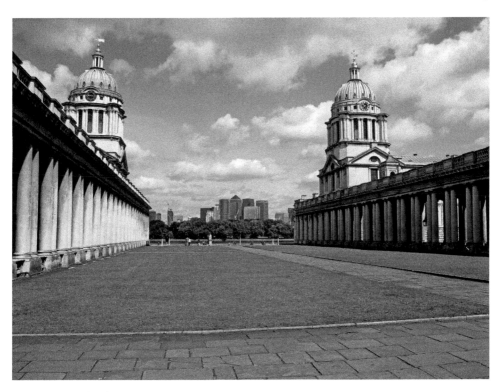

Old Royal Naval College.

The huge collection of nautical art then transferred to the newly established National Maritime Museum, occupying the Queen's House and adjoining buildings – previously the Greenwich Royal Hospital School – where children from seafaring backgrounds were boarded and educated. Boys at the school were prepared for a career at sea and girls for working in domestic service. Of around 10,000 boys educated at the school between 1874 and 1930, five rose through the ranks to attain the position of admiral. When Greenwich Royal Hospital closed in 1869, over 20,000 pensioners had passed through the hospital's care since inception, the charity turning its attention to raising income to pay pensions and educating children. The Royal Hospital buildings were taken over by the Royal Navy in 1873, becoming the Royal Naval College, an educational facility for naval officers. Towards the early twentieth century, Greenwich Royal Hospital School was becoming increasingly overcrowded, relocating to new facilities at Holbrook, Suffolk, in 1933. The Royal Naval College then transferred its activities to a new base at Suffolk in 1998, a nuclear reactor, known as Jason, located within King William's Quarter, was removed at the same time, along with over 250 tons of nuclear waste. The reactor was one of very few operating in a highly populated area, a majority of the people of Greenwich unaware of Jason's existence. Currently home to Greenwich University and the Trinity School of Music, the magnificent Old Royal Naval College buildings and grounds are open to the public, and often used as a location for television and film productions, including early classics such as *Indiscreet* staring Cary Grant and Ingrid Bergman, *The Charge of the Light Brigade* with Trevor

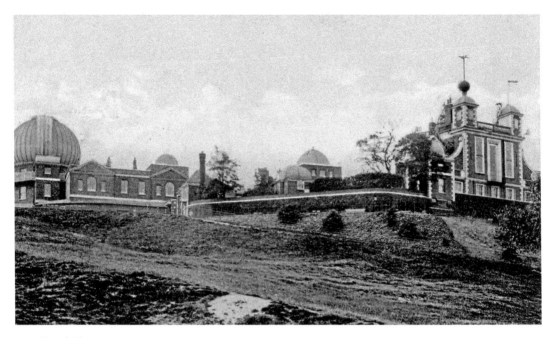

Royal Observatory.

DID YOU KNOW?
A large sum of money used to build Greenwich Royal Hospital for Seamen, later to become known as the Royal Naval College, came from confiscated treasures of pirate Captain Kidd.

Howard and John Gielgud, and *Murder by Decree*, a Sherlock Holmes adventure where the Victorian sleuths are on the hunt for Jack the Ripper, the character of Holmes played by Christopher Plummer and Dr John Watson portrayed by James Mason.

Although Greenwich visitors today may well come across actors and extras dressed in period costume when filming takes place within the college grounds, there was a period not too long ago when retired sailors, serving officers and young trainee ratings were a common sight on the streets of Greenwich. The old pensioners, dressed in traditional dark blue frock coats and tricorn black hats, frequented local inns and taverns, and young naval cadets out on parade, accompanied by the beat of a drum or a well-recognised nautical tune played by the band, marched through the streets of Greenwich. When work begun on constructing a new palace for Charles II, the king commissioned the building of an astronomical observatory in 1675, designed by Sir Christopher Wren, the Royal Observatory built on Castle Hill in Greenwich Park at the site of the old Greenwich Castle. The Tudor fortification had been used during the seventeenth century as the residence of the park ranger and for billeting soldiers sent by Oliver Cromwell to form a

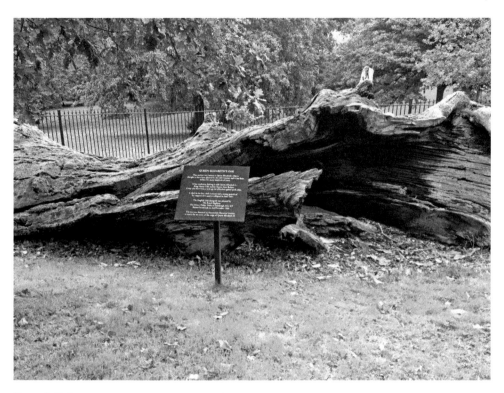

Queen's Oak.

preventative task force to stop the poaching of deer. Once the site had been cleared, the Royal Observatory took just under a year to complete, built from salvaged material from the Tower of London and unused bricks from Tilbury Fort in Essex. Charles II appointed John Flamsteed to the role of astronomer royal, with the main observatory building then named Flamsteed House. To the front of the Royal Observatory visitors are able to straddle the Prime Meridian, the 0^0 line of longitude, standing with a foot in the western hemisphere and the other in the eastern hemisphere. Further additions were added to the building for the housing of various telescopes, and in 1833 a Time Ball was installed at the top of the left-hand turret of Flamsteed House, the ball rising and falling at 13.00 hours, a signal for ships on the Thames to set their marine chronometers. The instrument used to determine accurate longitude at sea had been designed by clockmaker John Harrison, a native of Yorkshire, who travelled to Greenwich seeking support and assistance from the second astronomer royal and a commissioner of longitude, Edmond Halley, famed for his comet discovery.

Greenwich Park has had long associations with British monarchy ever since it was first used as a royal hunting ground after the Norman Conquest. Towards the park's centre a tall tree, dating to the twelfth century, known as Queen Elizabeth's Oak, was held up by twisted branches of ivy after dying during the nineteenth century. According to legend, Henry VIII and Anne Boleyn danced around its base and Elizabeth I took refreshment under the shade of its leafy green canopy when riding out from Greenwich Palace. The

oak was also used to detain park criminals within its hollow trunk, locked up behind a heavy wooden door. The ancient tree came down during a torrential rain storm in 1991, the remains left where they fell and a new oak sapling planted close by. To the south-west corner of the park, near Chesterfield Gate, are the remains of Queen Anne's sunken bath, all that is left of Montague House where the estranged wife of George IV resided between 1798 and 1813. Montague House was notorious for raucous parties held by the queen, the revelries becoming the talk of all London society. The house of ill repute was then pulled down after Queen Anne left England for Europe.

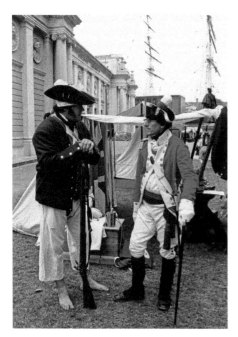 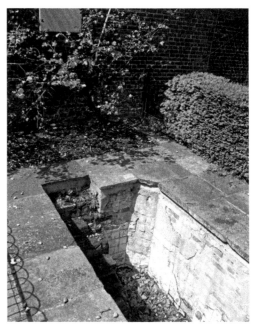

Above left: Historical Maritime Society naval re-enactors performing at the Old Royal Naval College.

Above right: Remains of Queen Anne's Bath, Montague House.

2. Green Spaces

The Royal Park and wide expanse of Blackheath are the two most well-known green spaces within the Royal Borough of Greenwich. The historic park grounds, laid out to a seventeenth-century design, contains various secluded gardens. Located behind low bow top metal boundary railings to the south of the park is the large Edwardian flower garden where during spring and early summer months the garden is adorned with bright, colourful seasonal flowering plants and foliage laid out in beds and borders among well-maintained plush green lawns, tall mature Cedar trees and flowering Tulip trees, offering picnickers shade on sunny days. Towards the western Flower Garden boundary is a small lake, the habitat for various species of waterfowl, where children over many generations have fed ducks with crumbs of bread. Hidden away in the south-east corner of the park is an area known as the Wilderness, where red and fallow deer kept in a large paddock can be seen from various discreetly positioned viewing areas located at the end of secluded woodland pathways. The deer once roamed freely throughout the park to the delight of the visitors up until 1927 when several deer died after being fed unsuitable food by the public. During the Tudor period there was a significant drop in deer numbers

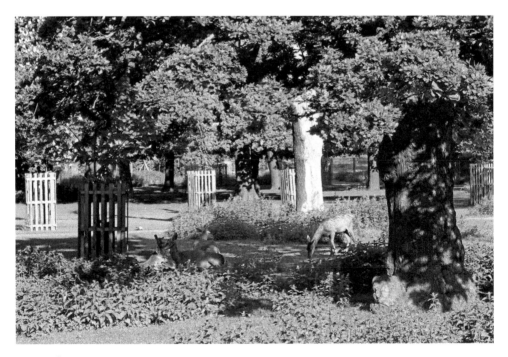

Deer Park.

caused by over hunting and poaching. The park was restocked with deer from herds at Rayleigh Park, Essex, at a cost of £60, equivalent to around £50,000 today. A Secret Garden Wildlife Centre, opened in 2002 with support from the Friends of Greenwich Park, utilised a derelict building situated among a dense row of trees running alongside the deer enclosure. The centre is open at specified times throughout the year where the deer, along with other wildlife, can be observed through the education centre's one-way glass viewing window.

At the park's south-western boundary, a spectacular rose garden set out behind a low yew boundary hedge forms a backdrop to the Georgian-built Ranger's House. Planted during the 1960s, and redesigned in 1995, the rose beds are arranged in concentric semi-circles, offset by a single large tree. The garden contains over a hundred rose varieties, a majority consisting of hybrid teas and floribunda flowering between the months of June to October. The blooms include a multitude of bright vibrant colours and varying delicate pastel shades. The earliest English roses were wild varieties known as Old Garden or Species, from which ornamental roses were bred and selected for planting in ornamental gardens. The Tudors adopted the rose as a national symbol after the Wars of the Roses, Lancastrian Henry VII combining the white rose of the House of York and red rose of the House of Lancashire when marrying Elizabeth of York, the happy couple spending many years during their marriage at the Tudor palace at Greenwich. From the Avenue, a road running diagonally north-west through the park down towards St Mary's

Royal Observatory Garden.

Gate, an inconspicuously positioned entrance on the footpath leading up Castle Hill gives access to the secluded Royal Observatory Garden, known as the Lower Garden during the period John Flamsteed served as astronomer royal. Once used mostly as the kitchen garden for the Royal Observatory, the gardens are now laid out in steep planted terraces accessed by a network of foliage sheltered pathways.

At one time a subterranean passage connected Flamsteed House to the Lower Garden, close to a well telescope over 100 feet deep, where the astronomer royal would lie at the bottom making observations of the night sky; both the well and passage have since been covered over. Hidden away along the north-east park boundary is a stretch of land originally serving as an orchard and kitchen garden to the Queen's House, growing varieties of plants and fruits including quinces and medlars, popular during the seventeenth century for making jellies to accompany lavishly prepared dishes for royal banquets. The grounds were later managed as a wildlife garden until re-established as an orchard in 2012. Through the support of volunteers, pathways were restored, two wildlife ponds created and a variety of historic vegetables, fruit trees and flowers were planted. During the renovations a deep well was discovered close to the orchard entrance by Creed Place Park Gate, the well used for either drawing water or storing ice to preserve meat. The Queen's Orchard is open to the public on Sundays from Easter through to October. To the left of St Mary's Gate in the north-west corner of the park behind the Grade II-listed keeper's lodge, now a café, going unnoticed by many park visitors, is the park's formal herb garden planted with a variety of common culinary herbs including oregano, rosemary and chives, a variety of sages and mint, along with some less used herbs such as santolina, lovage, camphor and balsam.

DID YOU KNOW?

The top of Shooters Hill, the highest point in the Royal Borough of Greenwich at 102 feet above sea level, and where the ancient woods were once the haunt of highwaymen and footpads, was removed to decrease the steep gradient to aid early motorised traffic ascending and descending the hill.

The herbs are ornately laid out around a central contemporary fountain sculpture by Kate Malone. Although the Herb Garden is a recent addition to the park, redesigned in 1993, herbs have been grown in the park since at least the Tudor period, cultivated for use in the preparation of meals at the royal court. During the eighteenth century herbs grown in the park were also used for their medicinal and curative properties, prepared in remedies for ailments suffered by inmates at Greenwich Royal Hospital. South of the Herb Garden outside Gloucester Circus Gate, a pedestrian walkway opposite leads to a large half oval communal garden at Gloucester Circus. Surrounded by a black wrought-iron fence, the garden contains mature plane trees, a large lawn area and various perimeter shrubs. Designed towards the end of the eighteenth century by local architect

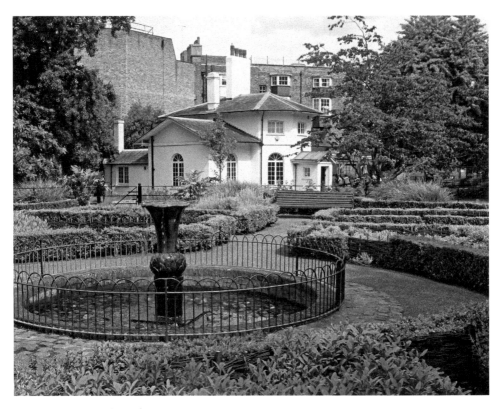

Greenwich Park Herb Garden.

Michael Searles, the circus was planned to form a full oval with two matching crescents of tall elegant properties erected each side of the green space, with an access road to the south-west leading to Royal Hill, named after the Victorian builder Robert Royal, and to the north-east a road leading onto Crooms Hill, originally an Anglo-Saxon thoroughfare running down from Blackheath. The project, however, ran out of money with only three-quarters of the development completed and instead of London's wealthier classes taking up residence as intended, the properties became dwellings of working class people. After the area suffered bomb damage during the Second World War, blocks of flats were erected on the north of the circus during the 1950s.

As West Greenwich became a fashionable place to live, the Regency buildings were renovated and are now one of most popular residencies of Greenwich. The Gloucester Circus Garden is accessible during annual garden open days, the residents serving tea and cakes to the garden's visitors. At the busy one-way traffic system encircling Greenwich Market, where traders now sell a range of arts, crafts, fashionware, curios and varieties of international cuisine, compared to goods on offer when the market was established in 1737, livestock, fruit, vegetables, fish, poultry and all kinds of meat – possibly deer poached from the park – visitors can take a break from the hustle and bustle of the busy market square and visit the secluded St Alfege Park. A haven of tranquillity within the busy town centre, the park is located along St Alfege Passage, one of a few surviving

Gloucester Circus Garden.

cobbled lanes of Greenwich, and is accessed through a pillared entrance within of a high brick-built boundary wall. Used as an additional churchyard of nearby St Alfege Church in 1803, the grounds soon became overcrowded and were closed to burials in 1853. Converted into a recreation ground in 1889, the park contains various mature trees, mixed shrub beds, herbaceous plants and grassed spaces. Rows of headstones dating from the nineteenth century stand upright around the park periphery, and various graves and monuments positioned in isolation surrounded by greenery towards the north-east corner of the park close to the old mortuary. A similar green space was created to the east of Greenwich, known as Pleasaunce Park, named after the Palace of Placentia, where the remains of around 3,000 naval personel, including many who fought at the Battle of Trafalgar, were reinterred when the rail tunnel to Maze Hill station was constructed in 1875, cutting through the burial ground of Greenwich Royal Hospital.

The naval graveyard was then transformed into a public park in 1926, with European lime trees planted around all four boundary walls, the branches pleached, tied together so the cambium – the inner branch tissue – self-grafted, an early Victorian method of training trees to form aerial hedges. The park has a large play area, a community centre and an eco-friendly café, the outer walls clad in steel mesh to encourage the growth of clematis, a climbing flowering evergreen plant. The Friends of the Pleasaunce hold annual community events including a summer festival with live music, arts, crafts and plenty of refreshments. With a majority of the Greenwich riverfront from the

St Alfege Park.

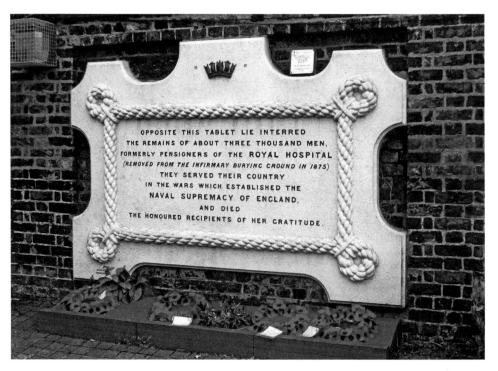

OPPOSITE THIS TABLET LIE INTERRED
THE REMAINS OF ABOUT THREE THOUSAND MEN,
FORMERLY PENSIONERS OF THE ROYAL HOSPITAL
(REMOVED FROM THE INFIRMARY BURYING GROUND IN 1875)
THEY SERVED THEIR COUNTRY
IN THE WARS WHICH ESTABLISHED THE
NAVAL SUPREMACY OF ENGLAND,
AND DIED
THE HONOURED RECIPIENTS OF HER GRATITUDE.

Pleasaunce Park Memorial.

Old Royal Naval College through to Greenwich Marsh, now known as Greenwich Peninsula, becoming heavily industrialised over the previous 200 years, very little green spaces, fields and marshlands were retained. A strip of rough land on the river's edge and a row of Georgian-built properties opposite, coming under threat of redevelopment during the 1960s, were saved by pioneer of the city farming movement Hilary Peters. The land was transformed into Union Wharf Nursery Garden and the row of houses rescued. The nursery later became a garden for the use of the residents of Union Wharf, the green riverside space consisting of a grassed lawn, plane trees, ferns, flowers and buddleias growing naturally on one of south-east London's earliest industrial wastelands. Easily missed by people taking a walk along the riverfront at Ballast Quay, the unique little garden is screened by greenery behind a low brick wall and wrought-iron railings.

DID YOU KNOW?

Tumbling down the hills of Greenwich Park became a popular activity for young couples when out walking during the early 1800s, the ladies encouraged to take part by their male companions during a time when dresses showed little apart from head, arms and feet, the tumbling motion exposing parts of the body usually kept well hidden.

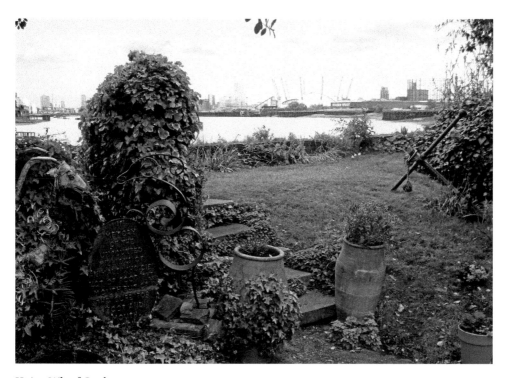

Union Wharf Garden.

Just inside the entrance gate there is a memorial dedicated to animals who died not from foot and mouth directly but from the wide-ranging culls carried out in an attempt to prevent the spread of the disease. The sculpture of a goat, created by artist Kevin Herlihy, uses discarded electronic parts and computer components that were washed up along the Thames. It stands upright on two hind legs supported by an ivy-clad tree. Various unusual pieces of sculptured art adorn the garden, positioned on the river wall or hidden within the green foliage. A brick-built structure to the east of the garden, now used to display the work of artists during open days, once acted as the office of the East Greenwich Steamboat Pier. Those visiting the garden today are encouraged to take time out and relax in the presence of two great powers of nature – the river and the plants. The redevelopment of Greenwich along the Thames has resulted in the demolition of a majority of the old riverside industries and buildings. Replaced by modern apartment blocks, hotels and entertainment venues, architects endeavouring to introduce green spaces laid out between the tall structures. Where workers once toiled in factories, workshops and riverside industries, residents can now exercise by jogging along a refurbished Thames pathway and through a maze of pedestrian walkways, plazas and piazzas, or work out at various lawned communal landscaped gardens. Before industrialisation Greenwich Marsh was also known as Greenwich Level, which, as the name implied, was an open level marsh. The marsh projected northwards with the river running in an upwards loop forming the west, north and part of the eastern boundary, a flood barrier, Lombarde's

DID YOU KNOW?

At one time pirates hanged at Wapping, opposite Deptford Dockyard, were exhibited in gibbets erected on Greenwich Marsh, their dead bodies tarred then left hanging as a warning to others not to take up the unlawful occupations of piracy and smuggling.

Wall, made up the remaining border, the south bounded by the main Greenwich to Woolwich thoroughfare.

By the early 1600s the marsh, used mainly for grazing livestock since the Middle Ages, had a protective sea wall built to hold back tidal surges with outlets to drain off floodwater. Prior to the 1800s there were few structures erected on the marsh, apart from a scattering of cowsheds and barns; however, it has been speculated that a Roman settlement was situated close to the where the O2 arena stands today. While no known archaeological evidence supports this theory, there were many local rumours suggesting Roman artefacts dug up during the exhibition centre's construction were secretly removed. After the marsh became heavily industrialised a majority of the natural environment and wildlife habitation was lost. When the regeneration of Greenwich Marsh took place towards the end of the twentieth century, leading up to the millennium celebrations, to bring back the

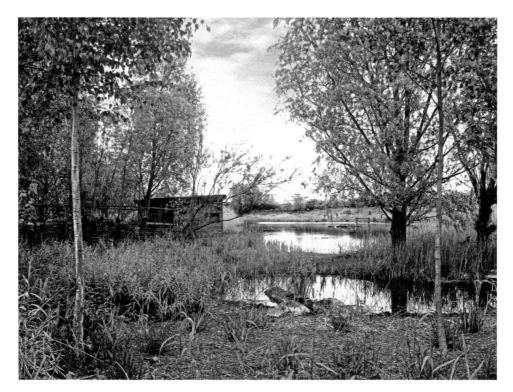

Ecology Park.

Ecology Play Park.

natural element of the marsh, an ecology park was created to the east of the peninsula over an area of 4 acres, made up of two lakes surrounded by natural marshland, resembling how Greenwich Marsh would have appeared before industrialisation. The park supports a variety of wildlife, birds, waterfowl, insects, frogs, newts and bats, and around the park boundary newly planted woodland areas consist of alders – trees that thrive in waterlogged conditions. Built as an extension to the ecology park, a children's adventure playground has been created using reclaimed materials to make a willow tunnel, timber swing and climbing tower. The ecology park is open to the public daily, organising various wildlife and ecology educational activities and community events throughout the year. A redundant coal jetty, situated between the ecology park and North Greenwich Pier, once used to offload coal to fuel Blackwall Point Power Station, was renovated for reuse as a performance venue, bar and restaurant, before being transformed into a greenhouse oasis for the project, Beyond Sustainability, created to promote, support and rejuvenate the urban greenery on Greenwich Peninsula. The jetty is planned to be opened throughout the year when locally organised seasonal events, festivals, educational and community-led projects are expected to take place.

The Jetty.

3. Going Underground

From the south of Greenwich Park boundary, the wide expanse of grassland of Blackheath, the name believed to have been associated with the Black Death of 1665 where the bodies of plague victims were buried, was first known as Blachehedfeld, as recorded in 1166, meaning dark coloured soil, becoming almost black when wet. Evidence of prehistoric activity on Blackheath was discovered in a cavern under Point Hill, where tools made from antlers found inside were used to dig out the shelter. A variety of Roman artefacts have also been unearthed from across Blackheath including bones discovered in the garden of Dartmouth House to the west of the heath, and a medal and axe found at Westcombe Park Road to the east, items that may well have been dropped or discarded by Romans travelling or making camp near the Roman route of Watling Street, which ran across the north of the heath, through the corner of Greenwich Park and onwards to Deptford. Many myths and legends were associated with caves, caverns and tunnels below Blackheath and Greenwich Park, with several believed to have been used by ancient Druids for carrying out pagan rituals and worship of Herne the Hunter, a spirit of the forest. Other caverns were used as deneholes, dug into the subsurface chalk by settlers hiding from hostile invaders, the word denehole, also known as Dane Hole, a derivation of the Anglo-Saxon

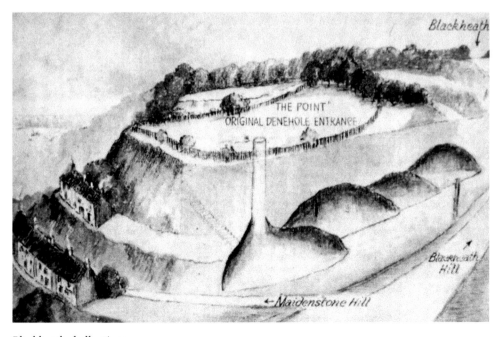

Blackheath chalk mines.

'den', meaning 'hole or hollow'. The rebel Jack Cade and a force of some 5,000 men made camp on Blackheath in May 1450, local legend suggesting that he held meetings with his cohorts in a cave below the heath, later to become known as Jack Cade's Cavern.

In all probability, the cavern had been in use prior to the rebellion, where an altar once stood and the figure of a horned god was carved into the wall, the cavern supposedly a place of pagan worship. A majority of caves and caverns under the heath were created for more industrious activities rather than for the adulation of an ancient god, the chalk dug out supplying Blackheath lime kilns, the processed chalk making lime for use in building materials. The first kilns were believed to have dated to the Elizabethan period. The production of lime was ordered to be stopped when the queen was holding court because of the overpowering smell and thick smoke drifting out towards Greenwich Palace. A local family, the Steers, were mining chalk and making lime at the time of the Great Fire of London, and as the closest source of chalk to the city, Blackheath processed lime was used to make mortar for the rebuilding of London. Extensive mining of chalk carried on throughout the seventeenth and eighteenth centuries, which caused the collapse of roads into the workings. By 1725 mining on Blackheath had come to an end, and the cave entrance at Maidenstone Hill was blocked up, although this did not stop further subsidence across the heath. In 1798 it was reported in the *Gentleman's Magazine* a horse disappeared down a hole that suddenly appeared in the ground. The most recent incident

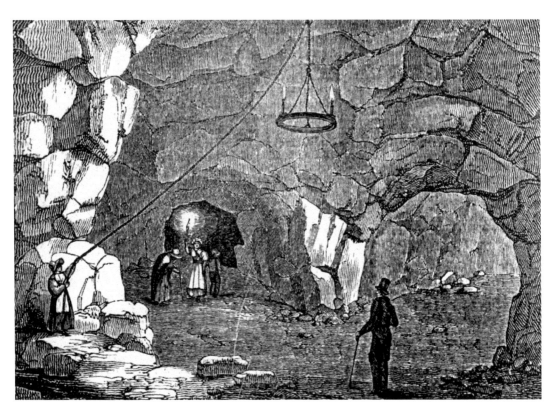

Blackheath Cavern.

of a road collapsing caused the closure of Blackheath Hill for several months in 2002, when large sections of the A2 fell into subsurface caverns.

DID YOU KNOW?
Greenwich has its own beach, located opposite the Old Royal Naval College riverside gates at the foot of the King's Steps, where during the Victorian period local residents would go for a paddle and a picnic at low tide, even though the river at that time was full of sewage, which flowed out into the Thames from underground tunnels.

The mines opened as a tourist attraction in 1780, known as the Blackheath Caves, the owner of Cavern Cottage, located next to the entrance, charging 6d entry fee. It was reported at the time that a young woman, Lucy Talbot, on returning from the caves to the surface fainted and subsequently expired. After her death, a ventilation shaft and bellows were installed to pump in fresh air when drinking parties and masked balls were held in the caves during the 1800s. The frivolities became such disorderly affairs that the local authorities closed them down, banning further such events from taking place. Although a survey was carried out during the war to determine the suitability of the caves for use as air-raid shelters, when they were found to be unsound the entrance was closed up

Hyde Vale conduit head.

again. Various caverns and tunnels also existed below several properties on Blackheath. One entrance was discovered when a stone slab was lifted up in the scullery of Macartney House, at the top of Crooms Hill, once home to the parents of Major General James Wolfe, remembered for his victory over the French in 1759 at the Battle of Quebec. In the 1800s a brave group of individuals clambered down a large hole discovered in the garden of a property at Hyde Vale. After descending some 10 feet, they were said to have heard running water, the area allegedly full of hidden springs. The party carried on downwards, arriving in a dark, damp chamber cut into the white Thanet Sand lined with bricks where sluice gates controlled the flow of water along brick-built conduits large enough to walk through upright, the conduits, running below Blackheath and Greenwich Park, once carrying water to the Palace of Placentia.

The earliest reference to a subterranean watercourse was recorded in 1268, the Arundel Conduit taking water to stables belonging to the crown at Ballast Quay. Although water was drawn up from various wells once located below the heights of Blackheath, one of which, the Stock Well, was situated near present-day Stockwell Street, the water would often be tainted and unsafe to drink. The brick-built conduits, however, supplied much cleaner water after groundwater had percolated down through the earth, which acted as a filter, the water supplying the palace and later Greenwich Royal Hospital. St Alfege Vicarage on Park Row, constructed across the old park wall, contains a square red-tiled

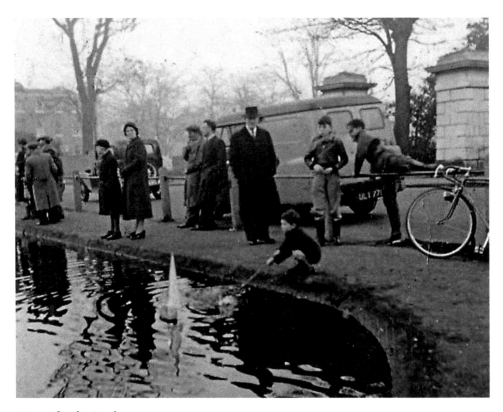

Prince of Wales Pond.

brick-built structure where a cistern fed by water running through a conduit from One Tree Hill also supplied water to the old palace. Although known as King Henry VII's room, the brick chamber is believed to predate the Tudor period. Several conduit heads, which served as an access to the conduit system, were erected towards the high ground of Blackheath – one surviving head can be found at the top of Hyde Vale on the corner of West Grove. When built around 1710, the conduit head was located close to a place known as Chocolate Row where coaches travelling the Dover Road stopped for watering horses at Horse Pond, the aristocracy taking some fashionable new refreshment, chocolate, served at the Chocolate House at the end of the row.

The pond, also referred to as Chocolate Pond, was one of several on the heath formed when water filled pits dug to retrieve gravel used as ballast for ships, chalk for processing into lime and Thanet sand used for metal casting – the reason why an arsenal was established nearby at Woolwich for the making of bronze canons. Although Horse Pond has long since gone, four other livestock watering holes have survived: Long Pond, Mounts Pond, Hare and Billet Pond and Prince of Wales Pond, where boys and girls once sailed model boats. At one time the Prince of Wales Pond was a meeting place of the Blackheath Model Boat Club, where since 1928 members gathered to launch their vessels. World speed record breaker John Cobb, a regular attendee, used many model boat designs as inspiration when building full-size speed boats. Within Greenwich Park, obscured by surrounding greenery during the summer months, is the Grade II-listed Conduit House, attributed to the architect Nicholas Hawksmoor, Greenwich Clerk of Works between 1698

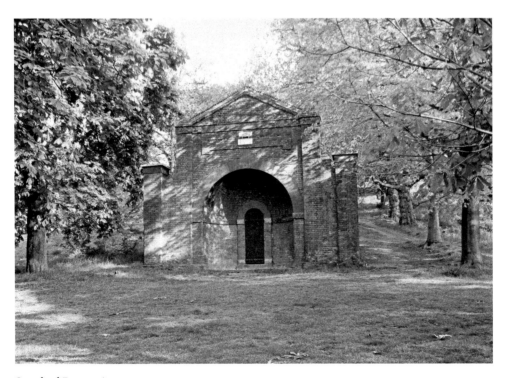

Standard Reservoir.

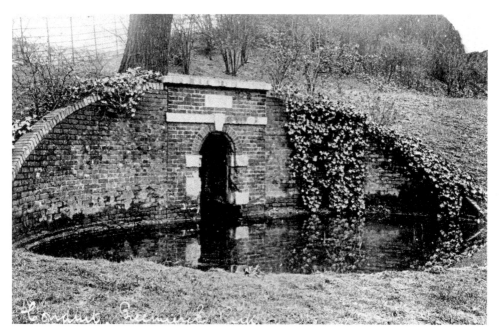

Conduit, One Tree Hill.

and 1735. Located to the south of King George Street Gate, the large single-storey building Standard Reservoir, constructed in brown brick with red-brick dressing under a tiled gabled roof, stored water fed through conduit pipes into a vaulted brick-built basement reservoir. To the front of the conduit house, a solid locked door set into a semi-circular alcove bars access to an entrance leading into a labyrinth of tunnels running below the park's surface.

Another conduit head, possibly designed by Hawksmoor, can still be found at the bottom of One Tree Hill, to the east of the park. The brick-built structure with an arched entrance has the appearance of an ancient doorway leading down into the underworld. Before it was made redundant, water once spilled out of the opening to form a shallow pool and people were able to walk through the entrance before iron bars were installed to prevent entry, the opening later being bricked up. Many myths and legends surrounded these dark, damp passageways, rumoured to run all the way to Neolithic caves at Chislehurst in Kent. The conduit system supplying water to Greenwich Royal Hospital closed when a reservoir was built on the western side of the park during the mid-nineteenth century and many of the conduit heads were dismantled. At the Old Royal Naval College several water pumps can still be discovered in situ within the grounds; one excellent example that has recently undergone renovation, although easily missed if not sought out, is located in the courtyard of the King Charles block. The pumps supplied water used by the pensioners for cleaning clothes, washing and drinking, although the residents preferred drinking beer brewed in the hospital brewhouse. When the building of the reservoir in Greenwich Park commenced in the mid-1800s, many Saxon burial mounds were dug up, prompting protests over the wanton destruction of these ancient monuments, the objections coming to the attention of Parliament.

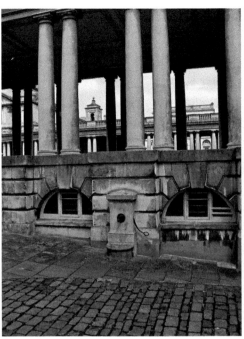

Old Royal Naval College water pumps.

Although the reservoir was ordered to be moved further south to preserve the remaining burrows, many Saxon artefacts had already been lost. Several of the mounds had been excavated in 1784 by Revd James Douglas, an elected fellow of the Society of Antiquaries and one of the first Saxon burrow archaeologists of the time. Douglas's finds included an iron knife, coloured glass beads, a spear head and some human hair. During the digging of the reservoir it was alleged a human skeleton was unearthed, leading to speculation the mounds were graves of ancient warriors killed in battle, or Cornish rebels buried after the Battle of Blackheath, although the confrontation took place near Deptford. The historic battle was the last engagement fought by Celtic warriors in London, the force marching from the West Country in response to high taxation levied by Henry VII to raise funds for a campaign against the Scots. A large mound on the heath, known as Whitefield's Mount and named after Anglican George Whitefield, one of the founding fathers of Methodism who preached at the mound during the eighteenth century, was believed to have also been a mass burial ground of the slaughtered Cornishmen.

DID YOU KNOW?

The oldest statue in Greenwich, a life-size figure of a Barbarian, dating from between the first and third century AD, was excavated in 1801 by British troops stationed at Alexandria, Egypt. On the detachment's return, the statue was erected outside the brass foundry at Woolwich Royal Arsenal.

On the opposite side of the heath where gravel was dug for use as ships ballast, accounts of ghostly apparitions were reported to have been rising up through the floorboards of a house at the top of Maze Hill. The servants, hearing strange knocking sounds going on throughout the night and believing the house to be haunted, gave notice to leave in fear of their lives.

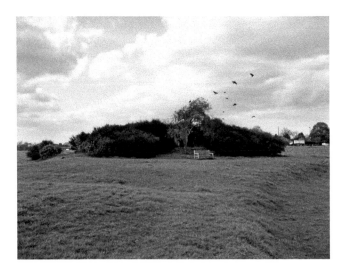

Left: Whitefield's Mount.

Below: Vanbrugh Castle.

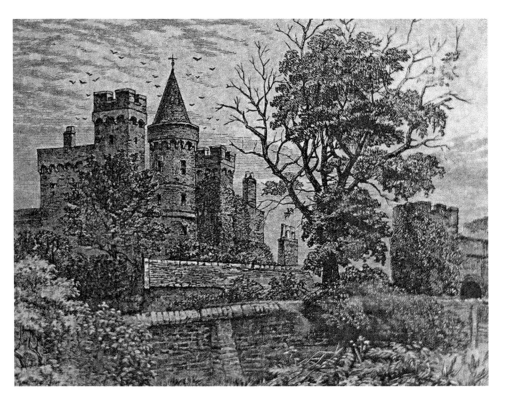

When a local constable made investigations into the unnatural activities, digging down into a hole at the rear of the property, he discovered the opening led to a den of thieves with their ill-gotten gains hold up in an old cavern under the house, the ghostly figures seen by the servants nothing more than wispy strands of smoke given off by the bandits camp fire. The den could once be accessed from a slope at the end of The Cedars, a large house adjacent to Vanbrugh Castle, the entrance, however, has long since gone. Designed and lived in by architect Sir John Vanbrugh and his family, Vanbrugh Castle was known to have tunnels running under the property, one leading down Maze Hill exiting into woods known as the Dell. After the castle was converted into a school in the early 1900s, enterprising schoolboys discovered a large underground room, naming it the Dungeon, where they hung out during the night listening to loud music while smoking woodbines.

DID YOU KNOW?

Greenwich Royal Hospital pensioners built their two-lane skittle alley in an underground passage below the chapel, using fake wooden cannon balls used in gun practice to knock the pins down.

From Maze Hill station close to the bottom of the Dell, a cut-and-cover rail tunnel was constructed in 1878 after a proposal to run a line across the front of the Royal Naval School was vigorously opposed by the prosperous citizens of Greenwich. Towards the western tunnel exit, a terminus built by the London, Chatham & Dover Railway at Stockwell Street in 1888 was named Greenwich Station, a rival to the station of the same name owned by South Eastern Railway. The line, running through a tunnel in a south-west direction to the existing Blackheath Hill station, was opened in 1871 and connected to the Nunhead to Lewisham link.

Royal Hill Community
Garden.

The line, however, failed to attract the number of passengers expected, and the station was renamed Greenwich Park to set it apart from the busier Greenwich Station. The line continued to lose money and was closed to passengers after the First World War, although the railway continued to run goods traffic up until 1929, when the line was then abandoned. Greenwich Park station survived up until the area was redeveloped in the late 1960s, first as billiard hall and then a timber merchants. The building was eventually demolished to make way for a hotel and car park. At Priory Street, the site of the old railway line, a community allotment, threatened by developers intending to build on the site, was saved by a local campaign and Priory Street Gardens are now protected under the Allotments Act. At another cutting on Royal Hill, a community garden created by local residents has also come under threat of development and has a less likely chance of survival. Blackheath Hill station, situated in a deep cutting at the bottom of Blackheath Hill, also became a billiard hall and then a builder's merchants, the tunnel from Greenwich used for storing bricks and as an air-raid shelter during the Second World War. After a new housing development was built on the old station site during the late 1980s, although the tunnel entrance was backfilled with concrete, part of the tunnel could be accessed by climbing down a flight of steps at the back of a workshop and entering by way of a wooden door, where you could then walk through into the dark abandoned tunnel.

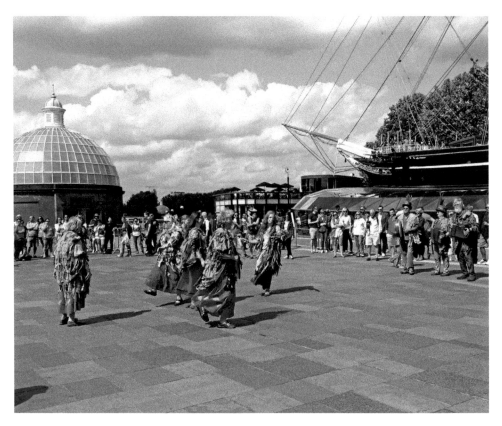

Greenwich foot tunnel and May Day celebrations.

Two underground tunnels easily accessed by the public are the foot tunnels of Greenwich and Woolwich. The Greenwich foot tunnel passes below the River Thames linking the south bank to the north bank at Island Gardens on the Isle of Dogs, the tunnel entered at each end by way of either a spiral staircase or an automated lift located in deep shafts below circular, brick-built, glass-roofed, domed structures. The tunnel, designed by Sir Alexander Binnie, was built as an alternative way for workers to cross the river rather than using costly and unreliable ferries. Constructed towards the end of the nineteenth century, the tunnel, clad in cast-iron rings, coated in concrete and lined with 200,000 ceramic tiles, is just over 370 meters long. The northern end of the tunnel was damaged by a falling bomb during the Second World War, requiring strengthening with steel panels and concrete. Although a byelaw prohibited people riding bikes through the tunnel, when lifts were operated by attendants cyclists remounted their bikes when out of view, the tunnel dipping towards the middle, riding swiftly through before being caught in the act by the attendant descending in the opposite lift. Constructed around the same period but opened after Greenwich, Woolwich foot tunnel, designed by Sir Maurice Fitzmaurice and built by Walter Scott & Middleton, is the longer tunnel by 104 meters. The circular red-brick-built entrance shafts, situated on each side of the river, are Grade II listed, the shaft building on the south bank reputed to be the oldest surviving structure in Old Woolwich. As with Greenwich, the foot tunnel was built to allow workers to move freely between their homes and workplaces either side of the Thames, the docks and shipbuilders to the north and the Royal Arsenal to the south.

Woolwich foot tunnel.

4. Heroes and Villains

Although having already briefly referred to the martyrdom at Greenwich of Archbishop of Canterbury St Alfege, the historic figure is worthy of further mention. Alfege, born into a wealthy Somerset Anglo-Saxon family, devoted his life to the Christian faith becoming a hermit at Deerhurst in Gloucestershire before rising up through the religious orders. Known for his kindness and courage, going among Norse pagan settlers and attempting to convert them to Christianity, Alfege was appointed Bishop of Winchester in AD 984, and by 1006 had attained the position of Archbishop of Canterbury. In 1011 Viking raiders laid siege to Canterbury, sacking the city and taking Alfege hostage. The Danes brought the Archbishop to their stronghold of Greenwich where for six months Alfege was held for ransom. Knowing his people would be unable to raise the sum demanded, the archbishop refused to allow payment to be made. During a feast coinciding with Easter Day, in a state of drunkenness the Danes pelted Alfege with the bones from their meal, then bludgeoned him with axe shafts. One Dane, believed to have been a Christian convert, out of compassion for the wounded archbishop killed him instantly with a blow to the head with the back of an axe. A miracle was then said to have occurred when a wooden Danish oar began to sprout after dipped in the martyr's blood. The death of Alfege was condemned throughout Christendom, nowhere more so than at the Abbey of St Peter at Ghent, title-holders of the manor of Greenwich. Canonised in 1078, a place of worship was established at the location of Alfege's death, with the words 'He who dies for justice dies for God', engraved on a stone slab in front of the sanctuary of St Alfege Church.

DID YOU KNOW?
St Ælfheah, known most commonly as Alfege, was the first Archbishop of Canterbury to suffer a violent death. Archbishop of Canterbury Thomas Becket, shortly before his own martyrdom in 1170, preached a sermon at Canterbury Cathedral referring to the death of Alfege, possibly knowing he had little time to live himself.

Rebels Wat Tyler and Jack Cade became heroic figures as leaders of the common people after rallying forces at Blackheath before advancing to London to protest against the oppressive governance of the people. Kent-born Wat Tyler led the first Peasants' Revolt of 1381, marching from Canterbury to Blackheath, then on to London, opposing the poll tax and demanding financial and social reform. Although achieving some initial success,

St Alfege Church.

after a disagreement with Richard II over terms of settlement, Tyler was attacked by the king's men. Tracked down after making his escape, Tyler was dragged back to Smithfield and unceremoniously beheaded. To the western edge of Blackheath where the rebels first gathered, a thoroughfare was named 'Wat Tyler Road' in his honour, many travelling its path most likely unaware of the road's significance. During the peasants' insurrection of 1450, a revolt against the corrupt governance of Henry VI, Sussex-born Jack Cade led his men to Blackheath after defeating a force of king's soldiers at Sevenoaks. Cade assembled reinforcements from where support was at its strongest, including Blackheath and north Kent, the encampment on Blackheath consisting of around 5,000 men, their leader occupying a cavern below the heath used as his headquarters. After a month gathering forces, Cade marched to London and took control of the city. When disorder broke out among the rebels, although in sympathy with the peasants' cause, the citizens of London forced the rebels back across London Bridge, the rebellion falling into disarray. Even though Cade and his followers were pardoned by the king, on his return to Sussex he was ambushed by the future Sheriff of Kent and killed. After Cade's death, the cavern where the leader of the rebellious peasants held counsel became a shrine to his memory.

Just over forty years after Cade's failed rebellion in June 1491, at the Palace of Placentia, Henry Tudor was born, the third child of Henry VII and Elizabeth of York, and second heir to the throne of England. Henry was educated at Eltham Palace, expecting his future to be in the service of his older brother Arthur. Following Arthur's death shortly after

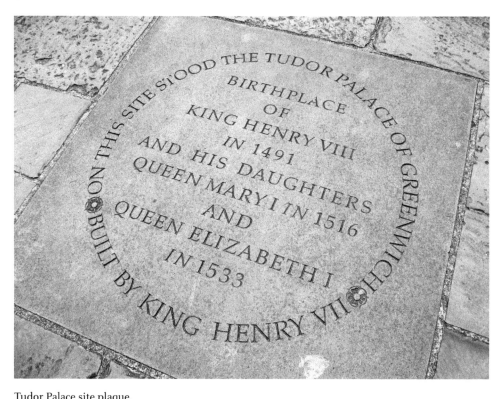

Tudor Palace site plaque.

marrying Catherine of Aragon, Henry was obligated to take over his brothers duties and would later take his sibling's widow as his queen. Before Henry's coronation he married Catherine at the Friars' Church, Greenwich, on 11 June 1509. For twenty-four years Henry and Catherine had a happy marriage, spending much time together at Greenwich Palace. While the king was away campaigning in France, Catherine, with Henry's full confidence, acted as Queen Regent, ruling and administering the country in his place. Even though the union was strong between Henry and Catherine, the queen suffered several miscarriages and still births, Princess Mary, born at Placentia on 18 February 1512, the only survivor of six pregnancies. Although the king doted on his daughter and her mother, Henry had been unfaithful to the queen on many occasions, fathering at least one illegitimate child, Henry Fitzroy. With the knowledge he was able to father a son, blame fell upon Catherine for not producing a male heir, and although a devout Catholic, Henry sought a divorce. After the request was denied by the pope, the king broke away from the Church of Rome to form the Church of England. Before the marriage was annulled, the king had intentions upon making Anne Boleyn, in the service of Catherine, his new queen. Marrying Anne at a secret ceremony in January 1533, an official marriage took place in May after Anne had fallen pregnant. Catherine was banished from court and her marriage declared null and void. Prior to Anne's coronation, four days of celebrations began with a river pageant, the barges and boats proceeding down the Thames from Billingsgate to Greenwich Palace, Anne boarding the royal barge and returning up river to stay at the Tower of London until

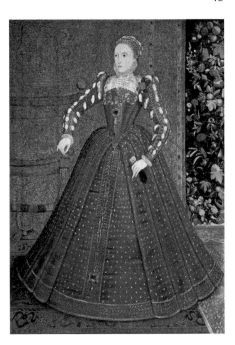

Queen Elizabeth at the beginning of her reign, c. 1563.

the eve of her coronation at Westminster. On 7 September of the same year, Anne gave birth to a girl at Greenwich Palace, the princess christened Elizabeth in honour of the king's mother Elizabeth of York.

After just three years of marriage without a male heir, the king decided it was time to find a new wife. Anne was arrested at Greenwich Palace and charged with adultery and treason. After Anne's execution, Henry showed little compassion for Elizabeth, the king declaring her illegitimate, depriving the princess of a place in the line of succession to the throne. When the king's third wife, Jane Seymour, died after giving birth to their son, Prince Edward, Henry arranged to meet his prospective fourth wife, Anne of Cleves, at Greenwich Palace, never having seen her apart from a likeness painted by Hans Holbein. The first meeting did not go well: when the king entered the palace chamber Anne did not acknowledge him, pushing away his advances when Henry attempted to kiss her. Although Henry found Anne unappealing, describing her as having the face of 'a Flanders Mare', the marriage went ahead as agreed by treaty, despite the king's protests. The marriage ceremony took place at Greenwich Palace on 6 January 1540, but was annulled just five months later. Upon Henry VIII's death, Edward, his only legitimate son, was crowned king at the age of nine, ruling under a council of regency and an appointed Lord Protector of the Realm. Edward, however, died at Greenwich six years later, and in due course was succeeded by half-sister Mary, and upon her death, Elizabeth, both holding court at Greenwich. Elizabeth spent the summer months at Greenwich where grand pageants and ceremonies were regularly held, including an assembly of London's men-at-arms, a lively river pageant where ships attacked an imitation castle, and a grand parade took place displaying treasures captured during England's defeat of the Spanish Armada.

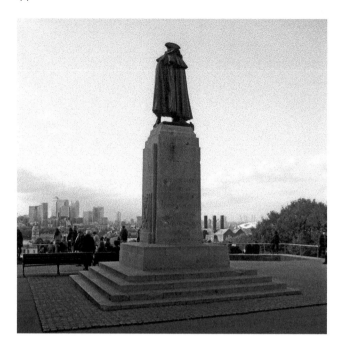

General James Wolfe statue.

DID YOU KNOW?
In February 1893, French anarchist Marctial Bourdin was killed when a bomb prematurely exploded while he was carrying it through Greenwich Park in the direction of the Royal Observatory, where he possibly intended to leave it.

In 1738 James Wolfe, son of distinguished general Edward Wolfe, moved with his family from Westerham to Mcartney House, Crooms Hill, Greenwich, residing there until joining up with his father's 1st Marine Regiment as a volunteer at thirteen years old. After receiving a commission as second lieutenant in the Marines, Wolfe transferred to the British Army Infantry, rising swiftly through the ranks. Coming to the notice of his superiors during the War of Austrian Succession, Wolfe was promoted to the rank of captain. Leading his regiment into action against the Jacobite army of Bonnie Prince Charlie at the battles of Falkirk and Culloden, Wolfe became famous for refusing direct orders to shoot dead a wounded highlander, exclaiming he would rather resign his post than sacrifice his honour, an act which brought respect and recognition among the Royal Highland Fusiliers, the regiment Wolfe later commanded during the campaign against the French in North America. At the age of twenty-three, Wolfe was appointed second-in-command of an expedition to capture the fortress of Louisbourg during the Seven Years' War with France, Wolfe attaining the rank of major general. After securing the fortress, the east coast of Canada came under the control of British forces, opening up a sea route for an assault on French held Quebec. Following a sea

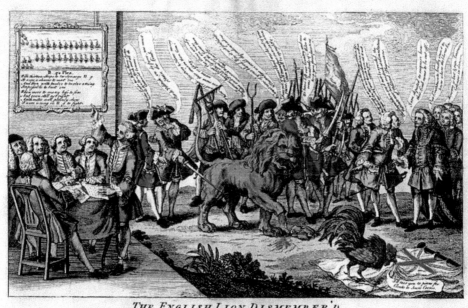

THE ENGLISH LION DISMEMBER'D

Or the Voice of the Public for an enquiry into the loss of Minorca - with Ad.ᴵ B. g's plea before his Examiners.

'Public Enquiry into the Loss of Minorca by Admiral Byng'.

battle and a long siege, Wolfe led a force of men to scale the cliffs west of Quebec on 13 September 1759, in a surprise attack on the French. In a battle fought out on the Plains of Abraham, the French capitulating after fifteen minutes of action, Wolfe was struck down, hit by three musket balls, one in his arm, the second in his shoulder and the third mortally wounding him in the chest. As he lay dying, Wolfe heard a solider call out 'They run, see how they run.' On asking who was running, Wolfe was told the French, with the Major General giving out his final orders to secure the city, he then cried out 'Now, God be praised, I will die in peace.' Wolfe's defeat of the French led to the capture of French-held Canada and the eventual creation of Canada as a nation. The body of the hero of Quebec was brought home aboard HMS *Royal William* for internment in the family vault at St Alfege Church.

At the outbreak of the Seven Years' War with France, the British-held stronghold of Minorca was invaded by French forces in May 1756, although a fleet of British ships commanded by Admiral John Byng had been despatched to defend the island. Admiral Byng's failure to secure the island and fortress after engaging French ships in a sea battle led to his controversial court martial. Byng, relieved of his command and ordered to return home, was charged with breaching articles of war and 'failure to do his utmost' to secure Minorca. Byng was held at Greenwich Royal Hospital prior to his court martial, preparing his defence in a secure apartment overlooking the Thames. At the court martial on a board ship at Portsmouth Harbour, although acquitted of personal cowardice, Byng was blamed for the loss of Minorca and sentenced to death for not carrying out his duty

as expected, the government ignoring the court's unanimous recommendation for mercy. Disgraced and made villain of this naval catastrophe, following his execution by firing squad, the broadsheets of the day speculated Byng had been made scapegoat over the loss of the strategically important garrisoned island, deflecting responsibility away from the Ministry of War for their initial lack of urgency in sending a task force to defend Minorca. For many years after Byng's death, the ghost of the much-maligned Admiral was said to wander the corridors of Greenwich Royal Hospital close to where he was held in confinement.

Just under fifty years later, the body of Vice Admiral Lord Nelson, shot by a French sniper during the Battle of Trafalgar, was returned to Greenwich Royal Hospital on Christmas Eve 1805 for lying in state under the magnificent mural ceiling of the Painted Hall. Nelson's lifetime naval achievements and his untimely but gallant death raised the vice admiral's heroic status to one of a national icon, where for three days Greenwich

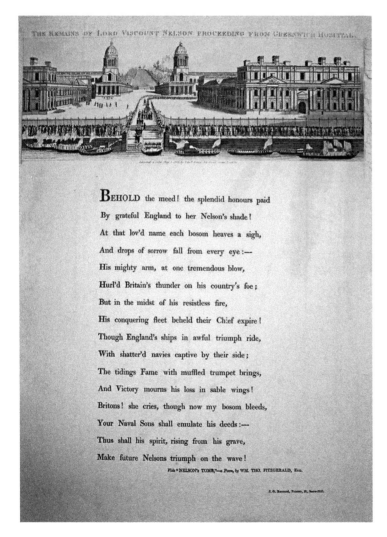

Poem for the laying in state of Lord Viscount Nelson.

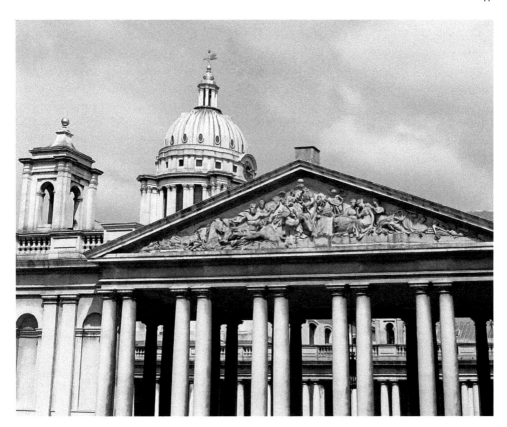

Nelson Memorial pediment.

streets were blocked by thousands of people queuing to view Nelson's coffin, made from the mast of the French ship *L'Orient*, salvaged after Nelson's victory at the Battle of the Nile. In honour of the valiant seafarer, several places in Greenwich were named after Nelson and his famous naval exploits including the thoroughfare Trafalgar Road, Nelson Road south of Greenwich Market, Nelson Arcade (an entrance into the market) and a stone memorial, and the Nelson Pediment, set in the architrave at King William Courtyard. Several public houses also bore names associated with Nelson: the Trafalgar Tavern, the Lord Nelson and the Admiral Hardy – Admiral Hardy was the commander of HMS *Victory* to whom Nelson uttered those immortal words as he lay dying, 'Kiss me, Hardy'.

In the same year of the death of Lord Nelson, a young spinster, once a resident of Greenwich, received little, if any, notable attention on her demise, even though she was one of the most notorious female fraudsters of her time. When the fashionable houses of the Paragon, Blackheath, were built, the first to take up occupancy in the exclusive and expensive properties were two young women, Eliza Robertson and Charlotte Sharpe, both supposedly governing a school for girls, Miss Robertson inferring she was heir to a Scottish estate. In reality both were on the run from apprehension for their involvement in a series swindles and frauds. As new residents moved into the Paragon, they began

having suspicions the spinsters were not who they seemed, and that Eliza was not only Charlotte's companion and friend but also her lover too. After running up huge debts commissioning local tradesmen to carry out work on the leasehold property and by expensively furnishing their rooms, promising to pay on completion, it soon became obvious they were living beyond their means when demands for payment were ignored. After running out of excuses why they were unable to pay their bills, Eliza and Charlotte fled to Suffolk. One tradesman the spinsters' owed money to, a carpenter, eventually tracked them down on behalf of other defrauded Blackheath tradesmen, however, as the bills had all been signed by Eliza, she alone was arrested and charged for acts of fraud. Found guilty and incarcerated at Fleet Prison, Eliza made an income by writing her autobiography and publishing books of poetry, the money allowing her to survive prison

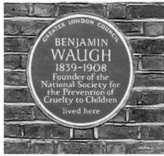

Benjamin Waugh Blue Plaque, Crooms Hill.

Crane Street and Turpin Lane.

in some comfort, having a furnished apartment and even a servant. In 1805, at the age of only thirty-two, Eliza passed away in prison.

Although there are currently fifteen English Heritage blue plaques erected on buildings in the Royal Borough of Greenwich dedicated to famous residents, including poet Cecil Day-Lewis, cartoonist Donald McGill, Astronomer Royal Sir Frank Dyson, writer Italo Svevo and, of course, General James Wolfe, no blue plaques have been erected on the Greenwich residencies of accomplished musician and inventor Charles Peace. The most likely reason for the absence of such plaques to remember Peace, who occupied residences at Turpin Lane and Crane Street, Greenwich, during the late 1800s, is probably because Peace was also an infamous murderer and burglar, and the most wanted man in England. Embarking on a life of crime after injury in an industrial accident as a boy, Peace shot dead PC Nicholas Cock during a burglary in Manchester and then murdered Sheffield businessman Mr Dyson, whose wife Peace was infatuated with. Soon after, in early 1877, Peace, on the run from the police, left the north taking up residence in Greenwich. Under the assumed name of John Ward, Peace then set up a family abode at Peckham with his wife, son, and mistress too. Professing to be a self-made man of means, a musician and scientific inventor – which had some basis of truth, as Peace was an accomplished violinist, often playing at music halls and public houses, as well as designing innovative engineering contraptions, which included a plausible method of raising sunken ships – a majority of his wealth came through burglary and swindling money out of prosperous families. Although a large reward was offered for information leading to his arrest, Peace, a master of disguise, evaded capture while operating freely in his one-man crime wave burgling houses of Greenwich and Blackheath. On the night of 10 October 1878, PC Edward Robinson, a well-respected officer among the community of Greenwich, was out

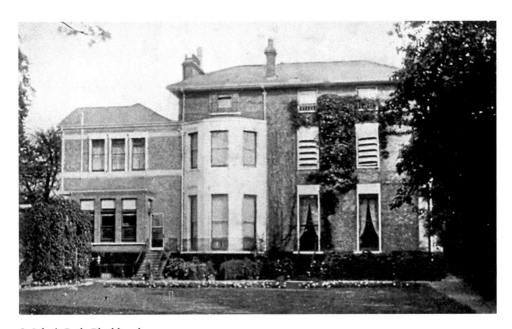

St John's Park, Blackheath.

on patrol at Blackheath, along with two colleagues, when he noticed a light flickering through the rear window of a large house at St John's Road. While the other two officers went to the front to investigate, Robinson made his way into the garden just in time to see the shadowy figure of a man climbing out of a window. On attempting to make his escape across the lawn, Robinson challenged the figure and was warned to stay back or be shot. The heavily built officer carried on with little regard for his own safety and was shot at five times. One of the bullets hit the policeman in the arm, and even though wounded and losing blood, Robinson jumped upon the assailant and grappled him down to the ground. Seeing the glint of light on the blade of a knife the burglar pulled, Robinson grabbed the pistol and coshed the burglar across the head, holding him down until his colleagues arrived. Although it was not known at the time, the heroism of Robinson had brought about the capture of the most wanted man in England, Charlie Peace. Giving a false identity, Peace was tried at the Old Bailey under an assumed name and found guilty of burglary and the attempted murder of Robinson. The real identity of Charlie Peace was revealed when betrayed by his mistress for the reward money. The Victorian master criminal was returned to Yorkshire where he stood trial and was convicted of the murder of Mr Dyson, confessing to the killing of PC Cock before being hung at Armley Prison, Leeds. PC Robinson received a reward for the capture of Charles Peace and an inscribed watch presented by the grateful residents of Blackheath, the officer becoming

DID YOU KNOW?
The only British prime minister to have been assassinated, Spencer Perceval, resided at Charlton House when he was a child, he and was buried in the churchyard of St Luke's, opposite the Bugle Horn, in 1812.

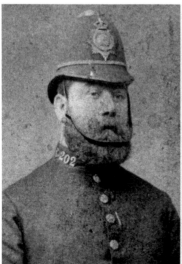

PC Robinson and Charlie Peace.

a local celebrity. After being promoted to sergeant, Edward Robinson was transferred to Whitechapel during the Jack the Ripper murders.

Author's note:
The hero and villain of this chapter's end have personal family connections, as PC Edward Robinson was my great-great-great-uncle on my father's side of the family, while the Victorian master criminal Charles Peace was my great-great-grandmother's godfather on my mother's side, both hereditary branches having no other associations until my father met and married my mother over seventy-five years later, when they discovered the historic ancestral connection.

5. Places of Notoriety

Greenwich, a place celebrated for its royal heritage, maritime history and industrial ingenuity, is famed worldwide for the grand colonnaded buildings of the Royal Naval College and the National Maritime Museum, two of the Royal Boroughs most famous historic buildings.

The *Cutty Sark*, a nineteenth-century-built tea clipper, conserved for posterity in dry dock, is the most well-known vessel of its time. Distinguished for the role the maritime town played in the means of accurately calculating a ship's position at sea, Greenwich was officially designated the home of the Prime Meridian. As one of Britain's most popular tourist destinations, Greenwich visitors usually head towards these most well-known landmarks, possibly missing out on discovering many secret places of Greenwich. Towards the centre of Greenwich Park at the end of a less well-trodden path, Lovers Walk, there is what appears to be an ancient prehistoric stone water fountain situated among tall grasses and shady elder trees. Although the fountain was erected during the mid-1800s, the stones used in its construction, Preseli Bluestone, are the same as those that

Cutty Sark clipper ship.

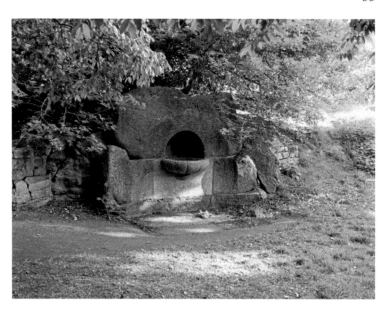

Mortherstone
Fountain.

form the inner circle of Stonehenge. The fountain was known by pagan worshippers as
the Motherstone, or Goddess Stone, once fed by water from a natural spring, and visitors
today occasionally discover flowers, crystals and spells left at the fountain as offerings to
Lillith and Hecate, dark goddesses of the new moon.

In 1688 land adjoining the park bordering Blackheath was divided into three plots, then
leased out by the Commissioners of Woods and Forests for the building of a house on
each – Montague House, Macartney House and Chesterfield House. Although Montague
House, one-time abode of Caroline of Brunswick, wife of George IV, was demolished in
1815. The house's pagoda, erected in 1767 to serve as a garden tea house, was left intact.
Occupying land adjacent to the house, the pagoda was built during a period when
Chinoiserie, a European interpretation of Chinese and East Asian art and design, became
particularly fashionable after merchant ships returned from the Orient with cargoes of
fine art, exotic silks, chinaware, spices and tea. The drinking of tea became popular in
the homes of the upper classes, many country houses having a Chinese- or Japanese-style
garden house built or room adorned with Oriental-style decorations, furniture and
porcelain for serving this new exotic beverage. The pagoda eventually fell into a poor
state of repair, and a housing estate, known as Pagoda Gardens, was built over a majority
of the grounds. Towards the late 1990s after the pagoda came under private ownership,
the building and the remains of the water garden were restored, and as part of the
National Garden Scheme the garden of the Grade II-listed pagoda was opened to the
public. Situated in a tranquil and sheltered position on Chesterfield Walk, Macartney
House, screened partially by a brick-built boundary wall, tall trees, greenery, and foliage,
can be easily passed with hardly any notice taken by people out for a stroll or heading
towards the park on the secluded pathway running alongside the house. Erected in 1694,
with extensions added during the mid-eighteenth century and early nineteenth century,
the property once belonged to the parents of General James Wolfe. In 1930 the grand

bronze commanding statue of Wolfe was erected with great ceremony adjacent to the Royal Observatory. The statue, a gift from the people of Canada, was unveiled by the Marquis de Montcalm, a direct descendant of the French Commander-in-Chief, Wolfe's opponent at the battle, who also lost his life on the day. To the back of the Grade II-listed monument there are several pitted scares across the stone plinth, caused when strafed by a German Messerschmitt machine gunning anti-aircraft batteries during the Second World War. On the central plot of land, an elegant Georgian villa was erected in 1723 by Captain Francis Hosier, a British naval officer who distinguished himself in action against the Spanish off Cartagena in 1711. After his death at sea, the lease was inherited by the 4th Earl of Chesterfield, the earl making various alterations and additions, renaming the property Chesterfield House.

DID YOU KNOW?
All Victoria Crosses awarded for acts of bravery since 1914 were made from sawn-off bosses of Chinese-made bronze cannons captured during the First Opium War. The bronze was held under lock and key in the vault at the Royal Logistics Store, Woolwich Royal Arsenal, and was only ever moved under guard.

Macartney House.

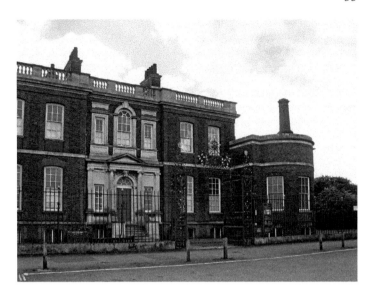

Ranger's House.

After exchanging tenure over many years, the house was passed to the Crown and in 1816 became the official residence of the ranger of Greenwich Park. Acquired by London County Council in the late nineteenth century, the house served as a sports and social club. Ranger's House is now in the care of English Heritage and home to the Wernher Collection, works of art assembled by diamond mine entrepreneur Sir Julius Wernher. Three rarely viewed pieces of art can be discovered at one of the least-known, but highly regarded, independently run museums of Greenwich, the Fan Museum, situated towards the bottom of Crooms Hill opposite Greenwich Theatre. Opened in 1991, the museum has in its collection over 5,000 fans and fan leaves from all parts the world, dating from the eleventh century up to the present day, including three pieces of unique original art, a fan design painted by Paul Gauguin, a fan decorated with a drawing produced by Salvador Dali, and a music hall scene painted on a fan by Walter Sickert, once suspected of being Jack the Ripper. The Fan Museum not only has an extensive permanent display of fans and fan memorabilia, annual themed exhibitions are held, including subjects such as mythology, animals, sports and leisure. The museum undertakes important conservation work to ensure the collection of unusual and unique objects of art are preserved for future generations. After viewing the museums exhibits, visitors can take afternoon tea in the mural painted Orangery, overlooking an ornate secret Japanese-style garden.

Although Blackheath was once the haunt of footpads and highwaymen, by the eighteenth century this illicit occupation had all but come to an end, the heath becoming a popular place for residential expansion as wealthy merchants, shipowners, city capitalists and prosperous entrepreneurs moved from the industrial smoke-engulfed capital to greener pastures. Towards the end of the 1770s, an elegant crescent of exclusive semi-detached Georgian town houses were built on the grounds of a demolished mansion, Wricklemarsh House. Sold by the heirs of Sir Gregory Page, stockholder in the South Sea Co., who increased his family wealth by selling his shares before the South Sea bubble burst, the manor was purchased at auction by John Cator, a Quaker and Member of

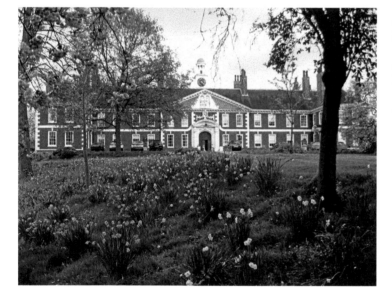

Above left: The Fan Museum.

Above right: The Fan Museum orangery.

Left: Morden College.

Parliament. Cator, having no use for the mansion, demolished the building, selling off the materials as salvage, and then built an exclusive Regency housing development named the Paragon, designed by locally born commercial architect Michael Searles. Erected in the form of a curved row, the symmetrical properties included façades, four bays wide, with a series of colonnaded terraces in between. The gardens, which all had a private freshwater well, varied in size, several of the larger plots including a carriage house and stable block. Although several houses were badly damaged during the Second World War, the Paragon appears much the same today as when first built, the exclusive properties likely to be the most expensive privately owned Georgian dwellings in Greenwich.

On the north-east corner of the Wricklemarsh Estate stands Morden College, a charitable institution founded in 1695 by Sir John Morden, a successful East India Company and Levant Company merchant, and highly respected Member of Parliament. Attributed to Sir Christopher Wren, the college building, erected as a home for merchants left destitute through loss of wealth through accidents, dangers and the perils of the seas, was constructed of red brick and white stone with an open quadrangle at its centre, around which ran a covered decorative stone block walkway beneath upper rooms supported by fine colonnades. The axial lines of the college corresponded to the points of the compass, the main entrance positioned to the west, the chapel and vestibule, to the east, the lodgings for inmates numbering up to forty single or widowed men. After Sir John Morden died, the charity was governed by an independent board of trustees.

DID YOU KNOW?

Lord Admiral Nelson's waistcoat and topcoat worn when he was shot during the Battle of Trafalgar was purchased from a private owner for £150 by Prince Albert, Queen Victoria's husband. The relics were donated to Greenwich Royal Hospital and are now exhibited in the National Maritime Museum.

Along the Greenwich riverfront, positioned next to the huge brick-built Greenwich Power Station, constructed between 1902 and 1910 to run London's electrified tram network, veiled by shrubs, bushes and a high wall, is Trinity Hospital Almshouse. Founded in 1613 by Henry Howard, the Earl of Northampton, the almshouse was erected on the site of Lumley House, once a residence of Robert Dudley and frequently visited by Elizabeth I when holding court at Greenwich. Set around a quadrangle cloister-style courtyard, the almshouse provided charitable accommodation for retired gentlemen of Greenwich, married couples later occupying the larger apartments. The Mercers Company took over the running of the hospital in 1621, and the front of the property was rebuilt in a Gothic style during the early 1800s.

The gardens at the rear, laid out with flora borders, contain various mature trees including a mulberry, believed to be a survivor of mulberries introduced into the country by James I, attempting to establish an English silk industry, the silk produced by the larva of moths feeding on mulberry tree leaves. Originally brought to Britain by the Romans, mulberry trees were grown for the edible fruit's medicinal properties. There are two types of mulberry trees, one producing black fruit the other white fruit. Unfortunately for James I, the majority of trees the king introduced were the black variety, and as the silk moth larva preferred leaves from the white, England's silk trade failed. Another ancient mulberry, believed to have been planted in 1608, possibly the oldest survivor in the country, grows in the grounds of Charlton House, considered the best-preserved Jacobean house in Greater London. Commissioned by the crown for Sir Adam Newton, tutor to Prince Henry, son of James I, Charlton House was built between 1607 and 1612,

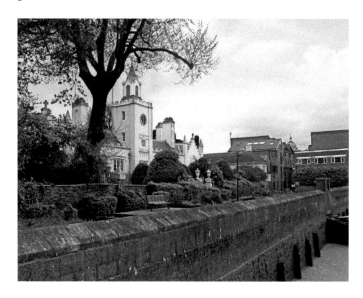

Trinity House.

constructed in red brick with stone dressing to an E-shape floor plan. The formally laid out estate gardens included a summer house orangery, attributed to Inigo Jones, situated next to Charlton Road at the centre of Charlton village close to where the old mulberry tree was planted. Charlton House, now a community centre, hosted the annual historic Horn Fair within the grounds, which by the eighteenth century had become known as the bawdiest in all of England.

Throughout Greenwich there are many statues and monuments dedicated to notable figures from history and significant events from times past. Known as the Sailor King, a nickname acquired after serving in the Royal Navy from the age of thirteen, a statue of William IV dressed in the uniform of Lord High Admiral stands high up on a plinth at the site of the demolished St Mary's Church, now the pedestrian entrance to the National Maritime Museum. The statue, the first in London to be made of granite and one of several having a rude appearance when viewed from a specific angle, was relocated to Greenwich from the junction of King William Street and Canon Street when road improvements were made in 1935. A statue of Sir Walter Raleigh, a court favourite of Elizabeth I, knighted for services to the crown at Greenwich Palace on the Twelfth Night of Christmas 1585, stands outside Pepys Visitor Centre entrance. Relocated to the National Maritime Museum grounds from Raleigh Green, Whitehall, close to where Raleigh was beheaded during the reign of James I after held captive for ten weeks at Greenwich Palace, the statue was moved to its current position in 2002. Other modern bronze statues of historic figures erected in Greenwich include Captain James Cook, appointed captain of Greenwich Hospital where he resided for a year before sailing out on his final fateful voyage, the statue erected outside the National Maritime Museum, Lord Horatio Nelson, a convalescent at Greenwich Royal Hospital after losing an arm, his life-size statue positioned close to the entrance of the Trafalgar Tavern, and Peter the Great accompanied by his court dwarf located to the front of modern apartments on the site of Deptford shipyard, where the Tsar of Russia studied shipbuilding.

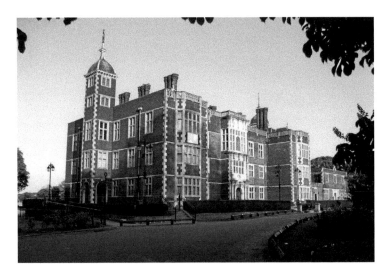

Charlton House.

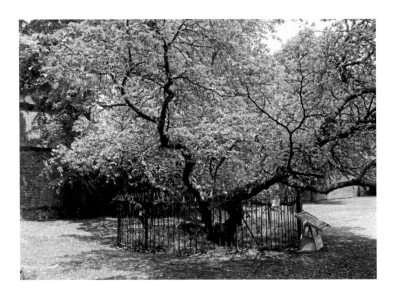

Charlton House
mulberry tree.

DID YOU KNOW?
General Charles Gordon, born in Woolwich, spent his last night in England at his
mother's family residence, Enderby House, before leaving for Sudan, where he was
later killed at the Siege of Khartoum defending the people against Mahdist forces.

Outside the Old Naval College grounds on an area of grass by the Thames side path,
where people sit on benches watching the river traffic pass by, a red-granite Egyptian
shaped obelisk, positioned behind the benches, bares the inscription 'BELLOT', the

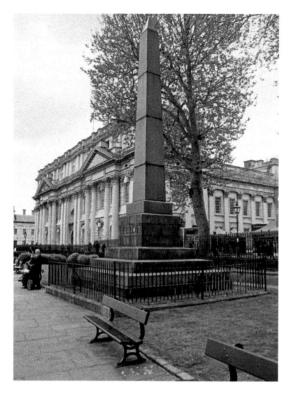

Bellot Mermorial.

monument dedicated to Lieutenant Bellot, a French explorer who embarked from Greenwich on HMS *Phoenix* as a volunteer in 1851 to search for Sir John Franklin, the expedition having gone missing in the Arctic. This was to be the Frenchman's last voyage as Bellot lost his life attempting to rescue two crewmates adrift on the ice. The memorial, paid for by public subscription, was erected in honour of his selfless act. At the time of Bellot's death, Franklin's own fate was unknown; however, several years later various relics of the expedition were discovered and the remains of two of Franklin's men were brought back to Britain, one of whom, now believed to be Dr Harry Goodsir, was interned in the Chapel of Greenwich Royal Hospital.

Devonport House, now a hotel and conference centre, had originally been built as a nurses' home adjacent to the Hospital School infirmary, a division of the Dreadnaught Seaman's Hospital complex opposite, the facility taking its name from the hospital ship hulk *Dreadnaught* once moored at Greenwich Reach. The nurses' home occupied the site of Greenwich Royal Hospital's burial ground, the remains disinterred and moved to Greenwich Pleasance, making way for the construction of a rail tunnel in 1875, the listed mausoleum for officers attributed to Nicholas Hawksmoor, built between 1713 and 1714, remaining within the burial grounds.

The mausoleum contains the bodies of Admiral Hardy, Lord Hood and Tom Allen, Nelson's personal servant aboard the *Victory*, the only non-commissioned officer laid to rest in the vault. To the front of Devonport House, a figure of Britannia stands atop of a high stone monument, erected in 1898, to commemorate the former residents of the

Greenwich Hospital
Mausoleum.

hospital once buried in the cemetery, and towards the garden railings by Romney Road
is a monument in the form of a pillar dedicated to Sir Thomas Boulden Thompson, also
buried in the mausoleum, one of Horatio Nelson's 'Band of Brothers' who fought at the
Battle of the Nile in 1798.

Opposite Devonport House within the grounds of the Old Royal Naval College stands
a weather-beaten early eighteenth-century statue of George II, dressed in Roman attire,
sculpted from a single block of marble weighing 11 tons. The block, discovered in the
hold of a captured French ship, was destined to have been made into a statue of the king
of France, Louis XV. South on Park Row, at the junction of Trafalgar Road and Romney
Road, the impressive colonnaded building Trafalgar Quarters, designed by hospital
surveyor John Yenn and erected in 1813, had been used as offices and a storeroom for
Greenwich Royal Hospital. Dwarfed in size by the adjacent neighbouring Old Royal Naval
College, the building was converted into accommodation for the servants of Greenwich
Hospital School, then lodgings for pupils in their first term. The building became the
quarters for officers attending the Royal Naval College in 1933 and when the Navy
moved out, Trafalgar Quarters were reclaimed by the hospital charity and converted
into residences for seafaring Greenwich pensioners, the first housed in Greenwich since
the pensioners moved out in 1869. At Greenwich Peninsula, a single monolithic slab
of red granite, dating to 1926 and inscribed with the names of seventy-nine workers
who gave their lives during the First World War, was relocated from the grounds of
British Gas works when the area was redeveloped during the late twentieth century.
Now standing in Central Park, a landscaped green situated among modern high-rise
apartments and studio complexes, the memorial serves as a reminder of not only those
who sacrificed their lives for their country, but also of a time when the peninsula was
an important place of employment and a busy and significant centre of manufacturing,
trade and commerce.

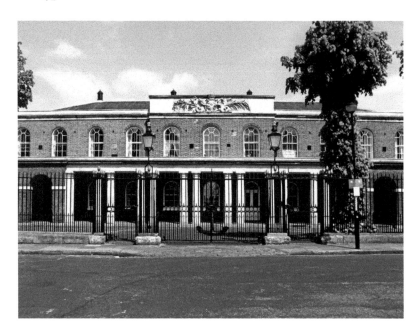

Trafalgar Quarters.

South Metropolitan Gas Company Memorial.

6. The Licensed Trade: Inns and Taverns

The ancient brewing traditions of Greenwich date as far back as the Saxon period when drinking beer was preferred to drinking water, which was often tainted, causing illness and even death. Beer and wine were relatively free from bacteria and the antiseptic properties of alcohol, as well as the natural acidity of wine and beer, killed off many life-threatening microorganisms. Medieval monasteries were important centres of brewing, and when Greenwich belonged to the Abbey of Saint Peter at Ghent, the Greenwich monastery would have included a brewhouse, the beer likely brewed in the Flemish tradition using hops rather than brewing conventionally un-hopped Saxon ale. By the reign of Henry VII, hops had been introduced into English brewing, both types of beer, hopped and un-hopped, continuing to be produced for many centuries after. Henry VIII instructed his own brewers not to use hops, the king preferring traditional, more wholesome English beer. Elizabeth I was also believed to have been an enthusiastic consumer of beer, the Elizabethan's drinking an average of around seventeen pints a week; however, there were harsh penalties for being drunk and disorderly, including the placing of the drunkard in the stocks. At Greenwich Royal Hospital, the pensioners were issued with two quarts of beer a day, brewed in the hospitals own brewhouse, after beer bought from local brewers was considered of poor quality. In 1829 a new brewhouse was built to the west of the hospital's main building, where a microbrewery serves beer to local residents and tourists today.

Even though Greenwich pensioners were supplied with regular beer rations, this did not prevent them from frequenting the many inns and taverns of Greenwich, the old salts

Microbrewery, the former Royal Naval College Brewhouse.

entertaining the locals in return for a pint of Porter or two by recalling their days sailing with Nelson's navy, fighting for England against fleets of Spanish and French ships, or chasing and hunting down ruthless, cold-blooded pirates. Because of the depredation caused by the over consumption of gin during the late eighteenth century and early nineteenth century, the government introduced the 1830 Beerhouse Act, which liberalised regulations for brewing beer, intended to encourage beer drinking as an alternative, the legislation increasing the number of breweries and brewhouses in Greenwich. During recent building works at Stockwell Street close to the old Stock water well, archaeologists uncovered the remains of a former malting, once supplying malt to local breweries and inns and taverns brewing their own beer. The buildings to the rear of the former Spread Eagle coaching inn on the old medieval route to London was used to store the grain and malt. In 1847, West Country brewers Lovibonds relocated to Greenwich, purchasing the Nag's Head on Creek Road (known then as Bridge Street) to establish a London brewery. Lovibonds then built a brand new brewery on land purchased from the railway close to Greenwich Station. Severely damaged by a doodlebug during the Second World War, the brewery buildings were repaired and Lovibonds were soon back brewing beer to sustain south-east Londoners during the Blitz. After opening various depots and branches throughout south London, the Greenwich brewery closed when Lovibonds were bought out in 1968, wine merchants John Davy & Co. purchasing the Greenwich brewery for use as a wine vault, and later a wine bar and restaurant. During the early Victorian and late Edwardian periods, when large numbers of people began relocating to Greenwich to take up employment opportunities created through the expanding manufacturing, maritime and riverside trades and industries, many public houses were built at the end of a row of terraced houses, or on the corner of a block of dwellings, erected to accommodate the workers and their families. Along with existing inns, taverns and beerhouses, by the early 1900s the number of hostelries in Greenwich had grown to over 150, several named after illustrious, celebrated historic figures, or notable historic events. The Trafalgar Tavern, named after Britain's seaborne victory over the combined French and Spanish fleets, became famous through visits by writer and social critic Charles Dickens, where

Lovibonds Brewery buildings.

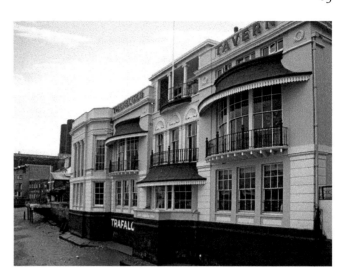

The Trafalgar Tavern.

Liberal Members of Parliament travelled by boat down river from Whitehall to dine on the tavern's renowned whitebait dinners. The Ship Tavern, one of the largest Greenwich inns, once situated on the present site of the *Cutty Sark* clipper ship, also served whitebait dinners, the Ship favoured by the Conservatives. As with many historic hostelries of Greenwich, the Ship Tavern suffered severe bomb damage during the Second World War and was later demolished. Other public houses lost during the Blitz included the Sea Witch on Greenwich Marsh, the Hatcliffe Arms off Blackwall Lane and the Kings Arms on Dutton Street, destroyed by a flying bomb.

As Greenwich came under residential and industrial redevelopment throughout the later part of the 1900s, many hostelries were either demolished to make way for new developments or converted for other uses. A majority of the remaining public houses continuing to serve beer to residents and tourists today have been extensively altered, their decor updated and names changed, very few retaining the character and ambience of times past. Around the busy town centre, public houses that kept their original titles include the Admiral Hardy, which once had a music hall attached, named after Nelson's flag captain at Trafalgar, the Spanish Galleon, built during the reign of William IV, the King's Arms, known by locals as the bunker bar, the nickname associated with a makeshift bar set up in the cellar where drinking carried on while bombs fell during the war, the Coach & Horses within the covered market square, and Ye Olde Rose & Crown believed

DID YOU KNOW?
Although there are two villages in Greenwich, Blackheath Village and Charlton Village, Charlton is the only true and genuine village as the thoroughfare between the Bugle Horn and the Swan public house is named simply as 'The Village', the only one in the whole of England.

DID YOU KNOW?
The Gypsy Moth public house, once known as the Wheatsheaf, was renamed after the yacht Sir Francis Chichester sailed solo in around the globe. The yachtsman was knighted for his record-breaking achievement by Elizabeth II in Greenwich with the same sword Elizabeth I used to knight Sir Francis Drake in 1581.

to have Elizabethan origins, rebuilt during the late 1800s on the site of the original inn and theatre. Many other Greenwich inns and taverns started out with one name before changing to another, such as the Wheatsheaf now the Gypsy Moth on Greenwich Church Road, the Barley Mow renamed the Yacht Tavern in Crane Street, and the Gloucester Arms opposite the park gates at King William Street, which became the Greenwich Tavern. By taking a walking detour away from the popular town centre, various secluded inns and taverns can be discovered on less well-known side roads of Greenwich.

Two public houses, the Richard I and the Greenwich Union, formerly the Fox & Hounds, are uniquely situated immediately next door to each other on Royal Hill, where beer has been served since at least 1869. Both were known then as beerhouses. By the late 1900s the Richard I was enlarged when the owner secured an adjacent property to expand the premises – one house became the public bar, the other the saloon. The beer house was taken over by Ipswich-based brewery Toollmache, later merging with the Cobbold Co. to form Tolly Cobbold Brewery; the Richard I then became known locally as the Tolly House. The Fox & Hounds continued operating under the same name until refurbished during the late 1900s, the name changing to the Observatory. When the Greenwich based Meantime Brewery was founded in 2000, the brewery took over the Observatory, the public house going through another refurbishment and name change to the Greenwich Union. The closet public house to the Meridian Line, the Plume of Feathers, lying just

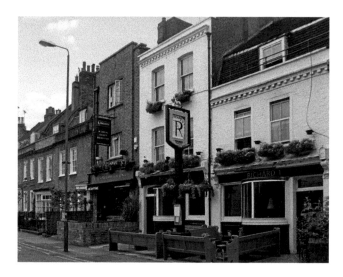

The Union Tavern
and Richard I.

The Plume of Feathers.

within the Eastern Hemisphere, is reputed to be the oldest surviving public house in Greenwich. Tucked away on a quiet side street – Park Place – when built in 1691, the inn was known as the Prince of Wales, situated on the main thoroughfare from the town centre. Stagecoaches, travellers and cattle drovers passing through the gatehouse of the Queen's House would have stopped off for refreshment at the Prince of Wales before heading out into the heart of Kent.

After landlady Jane Whitall took over the public house in 1726, the name changed to the Plume of Feathers, the heraldic emblem of the Prince of Wales, traced back to Edward, the Black Prince, whose eldest sister, Princess Isabella Plantagenet, was buried at Greyfriars Church, Greenwich. Unlike many local public houses, the exterior and interior of the Plume of Feathers has changed very little over the years. Run by independent landlords since 1999, the Plume of Feathers currently holds the Cask Marque Award for serving quality real ale, and continues to provide the charm and atmosphere of a village pub, although located in an extremely busy suburb of London. With the increase of traffic heading into Kent, a new wider highway was built during the late seventeenth century further north from Park Row towards the river, named Romney Road, the through road merging with Hogg Lane before heading eastwards onto Woolwich Lower Road. Various inns, taverns and staging posts were established along this busy route. Those that have survived include the Star & Garter erected during the early 1800s on the corner block of

The Cutty Sark Tavern.

terraced houses north of the main road, Hardy's, originally named the Bricklayers Arms, located within a row of shops on Trafalgar Road, dating to the mid-nineteenth century, and the Crown established around the same period. After the Trafalgar Tavern and the Yacht, the only remaining riverside public house close to Greenwich town centre is the Cutty Sark Tavern, dating to 1743.

First known as the Green Man, when rebuilt towards the end of the eighteenth century the name changed to the Union Tavern, the riverfront known as Union Wharf. In 1954, when the *Cutty Sark* was placed in dry dock and opened as a tourist attraction, the public house was renamed the Cutty Sark Tavern in honour of the famous tea clipper. Once frequented by river workers Thames Lightermen and Watermen, after the interior was refurbished during the late 1900s the Cutty Sark Tavern became a popular destination for new residents moving into the modern apartments gradually replacing the old riverside industrial sites. At the end of Ballast Quay on Pelton Road, there is a public house, built in 1844, with two names, the Pelton Arms and the Nags Head. When north-east coal merchant Cole Child's negotiated the leasing of Morden College-owned land to establish riverside wharfages for his expanding coal, cement and iron trading business into the south, he was required to financially support improvements made to land drainage and road access, along with providing a new residential development of smart terraced houses, including a public house erected at the end of the row. The public house was named the Pelton Arms, after Pelton Colliery, County Durham, the sign depicting a colliery headstock. Used as the location for filming the television production *Rock and Chips*, a prequel to the popular comedy series *Only Fools and Horses*, the Pelton Arms doubled as the Nags Head, Del Boy and Rodney's local boozer, the alternate name left in situ on the outside signage board after filming was completed. Hosting live bands at weekends, quiz nights and a knitting club during the week, in 2016 the Pelton Arms was voted south-east London's CAMRA Branch Pub of the Year.

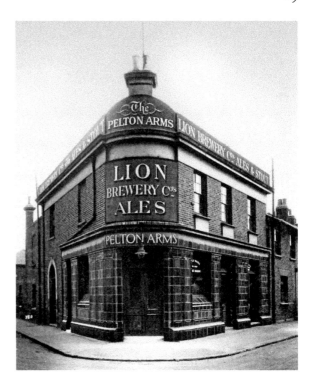

The Pelton Arms.

DID YOU KNOW?
Each December pairs of people dressed as pantomime horses take part in a fun-packed annual race on a course taking in many of the public houses at the centre of Greenwich, the pantomime horses having a beer in each to raise funds for charity.

At the opposite end of Pelton Road on the crossroads of Christchurch Way, the Royal Standard occupies the corner plot of the row of terraced houses, established in 1846, the Standard one of the few remaining side street public houses still frequented by time-honoured residents of Greenwich. Blackheath village, situated away from the crowded centre of Greenwich, has a charm and ambience suggesting a long and ancient history, however, the village is a relatively recent development in comparison to a majority of Greenwich districts. Before the mid eighteenth century all that occupied the south-west corner of Blackheath was a scattering of small properties on the edge of Wricklesmarsh Manor. Around the same period All Saints' Church was under construction, during the mid-1800s, properties began to be built along the main thoroughfare, Tranquil Vale, consisting of a number of substantially built houses, various shops, a school and several public houses. One of Blackheath's earliest taverns the Hare & Billet had existed long before the village, built around the mid-1700s as a coaching inn adjacent to a pond used for watering coach horses and drovers livestock.

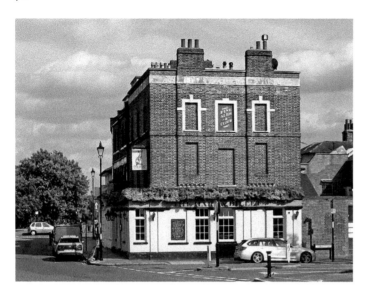

The Hare & Billet.

Although the inn has since been rebuilt, the Hare & Billet retains a supernatural connection to its past, as according to many local residents the shadowy figure of a woman dressed in Victorian clothes, believed to have hung herself from nearby elm tree after being jilted by her lover, continues to haunt the road outside. The village's other surviving public houses have also gone through various exterior and interior alterations over the years, including the Crown Hotel, the Railway Hotel and the Three Tuns Hotel, now known as O'Neill's. The Princess of Wales, located on the road leading across Blackheath towards Charlton, has historic associations with the famous Blackheath Rugby Club; the public house was used by the club's players and officials, and as changing rooms for the first ever International match between England and Wales played at Richardson's Field, Blackheath, in 1881. Two public houses recently saved for posterity are situated in close proximity to each other on the main road passing through Charlton village, an urban hamlet located between Blackheath and Woolwich on a high area of ground with a magnificent outlook towards Greenwich Marsh and the Isle of Dogs beyond. The Bugle Horn, which has associations with the boisterous Horn Fair, was established as a coaching inn during the eighteenth century, consisting of three cottages knocked into one, the inn a regular haunt of London day tippers venturing out to the countryside in horse-drawn carriages. After the popular landlord retired in 2015, the historic Grade II-listed public house faced closure and change of usage.

The Bugle Horn's slide towards obscurity was cut short when the pub's locals rallied together to keep the inn open and a new licensee moved in. A similar fate faced the White Swan, a near neighbour of the Bugle Horn, when bought by developers and closed. Although not as old as the Bugle Horn, the White Swan, built in 1889, the Swan was nevertheless just as popular with the people of Charlton village, both public houses regularly frequented by Charlton Athletic Football Club supporters on matchdays. The White Swan was eventually saved after a successful campaign to have the pub listed as an Asset of Community Value. Given a new lease of life, the White Swan was refurbished

The Bugle Horn.

The White Swan.

and reopened after coming under the management of the licensee of the Pelton Arms. The White Swan offers a variety of cask ales, distinctive bottled beers, excellent food and live music at weekends. As Greenwich Marsh became heavily industrialised, several public houses were built to serve the small community of workers on the marsh, the Sea Witch and the Star of the East, both believed to have been named after opium clippers built at Blackwall on the opposite side of the Thames, the Mechanic's Arms at Morden Wharf, the Mitre Arms built towards the end of the nineteenth century adjacent to the gasworks, The Ordinance Arms on Blackwall Lane, and the Pilot, dating to 1801, the first to be built on the marsh. There is also some historic reference of two other properties serving as public houses – the Salutation and Kenilworth Castle. The only public house to have survived either bombing during Second World War, change of use or demolition for land redevelopment is the Pilot. Once known as the Pilot Inn & Ferry, the name referring to pilot boats guiding vessels back and forth along the Thames, the first pub sign depicting a pilot vessel, it has been suggested the public house acquired its name in reference to a song sang at the inauguration of the Pitt Club, 'here's to the Pilot that weathered the storm', a tribute to former Prime Minister William Pitt after losing the general election the previous year. Pitt, along with his elder brother and several politians, were leaseholders of land on Greenwich Marsh, close to where tide mill owner George Russell built the public house. Situated at the end of a row of terraced houses, Ceylon Place, once occupied by Russell's tide mill workers, the Pilot was frequented by locals employed in the marsh and riverside industries, as well as the crews of boats and ships tying up at local wharfs and jetties. After Greenwich Marsh underwent regeneration, leading up to the millennium celebrations, extensive refurbishments were carried out to the Pilot, the building extended, bars enlarged and gardens landscaped, the adjoining houses of Ceylon Place were purchased and converted into hotel accommodation. The Pilot, the last surviving original public house on Greenwich Marsh, is just one of several historic secluded Greenwich hostelries well worth discovering.

The Pilot.

7. A Sporting Heritage

During the reign of Edward II the mass participation activity of mob football, a game of the people played on foot, not as the name implied, with the feet, was banned in London – the king said to have been disturbed by the adverse effect football had on the good citizens of the city. The game, a rough and ferocious affair, was played annually on Shrove Tuesday between participants from two rival communities. The objective was to carry an inflated pigskin ball to a specified place of the opponent, a wall, post or building, the first side to do so winning the contest, the only rule forbid murder or manslaughter. After growing in popularity the game was banned altogether by Edward III, concerned football was distracting men from practising archery when England was in need of archers after the country's fighting forces had been depleted following the Black Death. In 1477 Edward IV also banned an early form of cricket, the game also alleged to have interfered with the practice of archery, where at Shooters Hill, the name believed to have associations with the shooting of arrows, instead of perfecting their skills with the bow, archers secretly played cricket just an arrow's flight away from the practice ground. Although records refer to archery competitions taking place at Shooters Hill during the Middle Ages, towards the late 1700s the densely wooded surroundings had the reputation as a haunt of highwaymen; the name of the hill is also said to have connections to 'shooters' or 'shoot up hill' referring to rogues and scoundrels armed with pistols holding up stagecoaches travelling to and from London. The villains, after being caught and found guilty, were hung at gibbets on the Dover Road close to Sevendroog Castle, erected in the late 1700s, the folly hidden within ancient woodlands at the top of the hill.

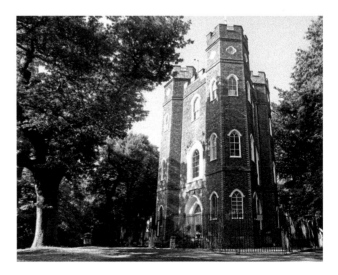

Sevendroog Castle,
Shooters Hill.

> ### DID YOU KNOW?
> Henry VIII excelled at various sporting activities including football, archery, tennis, bowls and jousting, and at 6 feet 2 inches tall and with a muscular physic when a young man, he was much bigger than a majority of men in his Tudor court.

In 1516, during Henry VIII's May Day excursion to Shooters Hill, the king and his first queen, Catherine, accompanied by members of the royal court riding out from Greenwich Palace encountered an outlaw with a company of tall yeoman dressed all in green carrying bows and arrows, the number estimated to be around 200. The leader, declaring he was none other than Robin Hood, addressed the king to ask if the monarch desired to watch his men shoot their bows. When the king agreed, the archers shot all their arrows simultaneously, causing a great whistling sound in the air, much to the amusement of the king and his entourage. The archers were not outlaws but members of the Henry's own guard dressed in the apparel of forest outlaws, putting on a show to entertain the king and watched by thousands of spectators. After the display, the royal party were invited to dine with Robin Hood and his merry men on roast venison and wine. The king's father, Henry VII, held archery competitions at Greenwich Park during the annual Grand May Day Games, other physical exercises including demonstrations of sword play, wrestling and weightlifting. To encourage the continued use of the bow, Henry VIII ordered his Master of Ordnance to form the 'Fraternitye or Guylde of Saint George' of longbows, crossbows and handgonnes, a military company that is second oldest in the world to the Vatican's Pontifical Swiss Guard. When England faced invasion by Spain during the reign of Elizabeth I, the fraternity was renamed the Honourable Artillery Company and for over 200 years archery continued to be even when the musket replaced the longbow as a hand-held weapon of war.

When archery became a fashionable pastime among England's aristocracy, the archers of the Honourable Artillery Company were formed into a private club in 1781, holding

Blackheath cricket match.

shooting contest at Blackheath up until the mid-1800s, and an annual grand archery meeting was held for competing clubs from all over the country. Not far from where the archers met on Blackheath, the modern game of cricket was also played, with three local clubs, Blackheath Dartmouth, Blackheath Paragon and Blackheath Morden, all founded during the mid-nineteenth century. One member of the Morden team, Montague Druitt, who was employed as a school master at George Valentine's School, Blackheath, was not only a feared opening bowler, he was also suspected of being the Whitechapel murderer Jack the Ripper. A first for Blackheath cricket took place in September 1868 when the Australian Aboriginal Cricket team toured Britain playing a match against Blackheath at Westcombe Park cricket ground, Blackheath winning the match by just thirteen runs. In 1886, Blackheath dropped Morden from its title and relocated from the Blackheath pitch to the Rectory Field, east of Greenwich Park, the ground named after the Charlton Rectory once occupying the site. A Parsee cricket team from India made their second tour of England in 1888, and played a match at Rectory Field against the Gentlemen of Kent cricketers, which ending in a drawn. The Blackheath Rectory Field was used as the regular venue for Kent County Cricket matches, mostly against Surrey, up until 1971. The Rectory Field was shared with Blackheath Rugby Club, the oldest open rugby club in the world, and one of the founding members of the English Rugby Union. Blackheath, or 'The Club' as they are known, were formed by the Old Boys of Blackheath Preparatory School in 1862, playing matches on Blackheath up until 1877 when a match was abandoned after

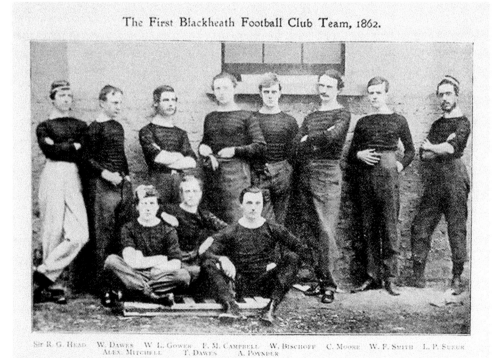

First Blackheath rugby team.

Tom Cribb Memorial.

spectators invaded the pitch. Moving to Richardson's Field, a more secure venue, the ground hosted several international matches including the first contested between England and Wales in 1881. The Club moved again in 1883, relocating to Rectory Fields, the venue later to become the unofficial home to England's International Rugby Union team preceding the development of Twickenham in West London. The Club were influential in the formation of the sport of Rugby Union, and in some respects the creation of Association Football after The Club refused to accept a rule change excluding hacking and holding the ball; from then onwards, rugby and football became two different ball sports. One famous fictional character, Dr John Watson, a friend and colleague of London's legendary private detective Sherlock Holmes, the creation of Sir Arthur Conan Doyle, is mentioned as having played rugby for Blackheath in the novel *The Adventure of a Sussex Vampire*. Sir Arthur Conan Doyle, an all-round sportsman, especially enjoying participating in the art of boxing, would undoubtedly have known of Gloucester-born pugilist Tom Cribb, who fought bouts on Blackheath during the early 1800s. At only 5 foot 10 inches tall and weighing around 14 stone, Cribb was not as big as many fighters of his day, however, he was a tough character, having the beating of much bigger and heavier men. In a match at Blackheath lasting eleven-rounds, Cribb won 40 guineas prize money, beating Tom Blake, a heavier and stronger man. Beaten only once in his career, Cribb was one of the country's eighteen leading boxers selected as ushers and pages for George IV's coronation at Westminster Abbey in 1821. After retiring from boxing, Cribb became landlord of the Union Arms public house near Piccadilly, later renamed the Tom Cribb, before moving in with his son and daughter-in-law above a bakery shop in Woolwich High Street. Cribb died in 1848, aged sixty-six, and was buried in St Mary's Churchyard,

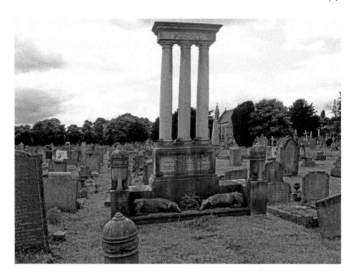

Thomas Murphy Memorial.

Fossa Sterope, champion greyhound.

Woolwich. A monument of a lion, sculptured by Timothy Butler out of one piece of stone weighing 20 tons and paid for by public subscription, was erected over Cribb's grave as a memorial to one of England's earliest boxing heroes. Another memorial, erected to the memory of sports and entertainments entrepreneur Thomas Murphy, owner of Charlton greyhound stadium, can be discovered in Charlton Cemetery, where two mournful life-size greyhound statuettes guard his grave. After the first British organised greyhound meeting took place at the Belle Vue track, Manchester, in 1926, Murphy opened Charlton greyhound stadium two years later. The most prestigious races held at Charlton were the Cloth of Gold, the Olympic and the Spring Cup. The greyhound racing visionary only lived long enough to see three years racing at Charlton, as he died in 1932 aged just thirty-nine. Following Murphy's death, the Charlton stadium shareholders liquidated the company and after coming under new ownership the stadium was completely rebuilt.

Authors note:

Three greyhounds Fossa Sterope, Fossa Mutt and Fossa Jeff, owned by my father Dave, his brother Charlie and family friend Ron Cook, raced at the local tracks of Charlton, Crayford and Newcross, Fossa Sterope, the most successful of the three dogs, winning many races and several trophies.

Charlton stadium had an annual turnover in excess of £1 million, however, the legalisation of betting shops in 1961 resulted in a fall in attendances and income. Racing at Charlton came to an end when the last meeting took place in September 1971; the track was closed and the stadium demolished. Greyhound racing had evolved from a type of hunting with dogs known as coursing, the hound running down live game such rabbits and hares. Henry VIII kept hunting hounds at Greenwich, as well as on the Isle of Dogs, across the river from Greenwich Palace, supposedly how the area acquired the name. Various breeds of dogs were used for certain types of hunting, greyhounds favoured for catching small quick game, bulldogs and mastiffs used to chase down boar, and spaniels worked for hawking, Henry building a mews for his hawks at an inner courtyard range at Greenwich Palace. An all-round sportsman, Henry was said to have been a much better shot than his gamekeepers and a better horseman than his grooms. Determined to ensure his jousting accomplishments would become famed throughout Europe, Henry spent lavishly on building new stable blocks and constructing a tiltyard at Greenwich Palace, which included twin observation towers connected by a gallery, the first permanent example in the country. The king also spent large sums of money holding tournaments at Greenwich, where men fought on horseback as well as on foot, Henry an enthusiastic and skilled participant in the jousts. During a jousting tournament at Greenwich in January 1536, Henry almost lost his life when thrown from his heavily armoured horse, which then fell on top of him. After the fall, the king was unconscious for two hours, and it has been suggested the accident may well have caused a permanent brain injury altering Henry's once genial and generous personality to that of a cruel tyrant. Before this incident, Henry enjoyed competing in various energetic sporting activities, including real tennis, played at an indoor court built at Greenwich Palace, and the early form of football – in 1526 the royal footwear collection was recorded as having forty-five velvet pairs and one leather pair for football.

Former Dial Square workshop, Royal Arsenal.

The game of football had been played by a majority of school boys and working-class men as a form of recreation, long before the sport became a professional occupation. In 1886 at Woolwich Royal Arsenal armaments depot workers formed a football team, Dial Square, named after their workshop, and by the early 1900s the club had evolved into Woolwich Arsenal, one of the most well-known football clubs in Britain. The Arsenal, as the club would later become known, played their home matches at a succession of venues in Plumstead, never actually in Woolwich, up until 1913 when the club moved to North London with the intention of attracting higher attendances. Before Arsenal relocated north of the river, a group of boys from Lower Charlton formed a youth football club, Charlton Athletic, in 1905. Charlton Athletic swiftly rose up through the local leagues after Arsenal moved north, taking over their neighbours place as the areas foremost football club. Known as the Addicks, a local pronunciation of haddocks, the nickname acquired through the club's association with Charlton Athletic's vice president, fishmonger Arthur Bryan, who served up haddock and chips to the players after matches. The club first played fixtures at Siemens Meadow by the river, the land owned by Siemens Telegraph Works, relocating to several other venues before moving to The Valley, a former sandpit quarry, after the First World War. At a committee meeting held at the Bugle Horn, Charlton Village, club officials made the decision to upgrade Charlton Athletic's status to senior amateur level.

DID YOU KNOW?
The first ever British football substitute used in a league fixture was Charlton Athletic's midfield player Keith Peacock, who came on in an away match against Bolton Wanderers on 21 August 1965.

After turning professional the Addicks joined the Football League in 1921. Although relatively successful, Charlton Athletic relocated to Catford in a proposed merger with

Charlton Athletic, FA Cup winners, 1947.

Catford-Southend FC. When the expected increase in attendances failed to materialise and the league blocked the merger, the club returned to The Valley the following season. Winning promotion to the First Division under legendary manager Jimmy Seed in 1936, Charlton Athletic won the FA Cup in 1947. Involved in several relegations and promotions over the next few seasons and another ground share with Crystal Palace then West Ham United, the club returned to The Valley after a successfully fought campaign by the fans to bring the club back home, and under new owners a majority of the ground was rebuilt. During the early 2000s, Rugby League club London Broncos shared The Valley for two separate seasons, the first professional Rugby League club to set up home in south-east London. One of the most unusual sports to take place at The Valley was midget car racing, when in 1948 the tour arrived in Britain. The racing series consisted of four international teams – USA, Belgium, Great Britain and France – sharing twenty midget racing cars between them, the race teams competing at various sporting venues around the country. The tour was promoted by Henry 'Bob' Topping, owner of the New York Yankees, the teams managed by Albert 'Cubby' Broccoli, who would later make his fortune and fame producing films. On 1 October 1661 a competitive sailing match took place on the Thames off Greenwich Palace, when Charles II, an experienced sailor who learned his nautical skills sailing Dutch jaghts, a single-mast pleasure vessel, while exiled in Holland, raced against his brother James, Duke of York, for a wager of £100. After the Restoration Charles commissioned the building of two royal yachts along the lines of the Dutch vessels, and on completion, the king, aboard the *Katherine*, and his brother, sailing on the *Anne*, raced down the Thames from Greenwich to Gravesend and back. According to John Evelyn, who was on board the *Katherine*, 'The King lost in the going, the wind being contrary, but saved stakes in returning.' From Evelyn's account, it would seem England's first yacht race ended in draw.

Competition rowing became a popular sporting pastime during the 1700s, evolving from a time when working row boats transported passengers and goods on the Thames, the first races starting as a contest between Thames Watermen, with prizes supplied by London Livery Companies and Guilds. One of the country's oldest rowing clubs, Curley, later known as Curlew, was established at Greenwich in 1787. To accommodate an

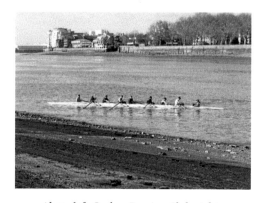

Above left: Curlew Rowing Club eights.

Above right: Annual Thames Barge Driving Race.

Thames Barge Race
Memorial Trophy.

increase in its membership during the mid-1800s, Curlew rented the Crown & Sceptre Inn as the club's headquarters until it was demolished in 1934. The rowing club moved to the Trafalgar Tavern, before establishing a new base, the Trafalgar Rowing Centre, at Crane Street. Over time many other forms of river racing took place on the Thames. In 1863 the first race for working Thames Barges was organised by Henry Dodd, a friend of Charles Dickens, the entrepreneur known as the Golden Dustman after building up his wealthy empire through moving London's rubbish by barge for disposal down river. The first races were organised to raise the status of the bargemen and improve the vessels sailing qualities; however, by the turn of the nineteenth century barges were purposely constructed to win the prestigious race, many of the vessels built at Greenwich and Charlton yards. One Greenwich-built barge, the *City of London*, won the race in 1887, another, the *Orinoco*, constructed in 1895, continues to compete in barge races today, the vessel believed to be the only surviving Greenwich-built sailing barge.

In 1974 members of the Transport on Water Committee met to explore ways to preserve the old skills of the Thames Lightermen who once moved goods about river on lighters – large floating containers powered only by oars and navigated through the Lighterman's knowledge of the currents and tides, a practice that had become mostly obsolete after the introduction of steam tugs to tow lighters about the river. Several lighters and crews were brought together and a short race took place from Tower Pier to Greenwich Pier. The race was so successful it attracted a lot of interest from prospective sponsors and the Thames Barge Driving Race became a popular annual event, the lighters driven over a course of 7 miles between the Palaces of Greenwich and Westminster. Each lighter is manned by crews of freemen and apprentices, the race designed to show their skills moving heavy flat-bottom lighters, which can weigh up to 30 tons, over the course under oars, known as sweeps, measuring 20 foot in length. No more than three crew members are allowed to propel the craft at any one time, two crew rowing, the third using a sweep at the stern to steer, each lighter collecting a pennant from stations along the course as a further test of the crews navigational skills.

Back on dry land, another sport requiring exceptional skill and precision to play well is the game of golf, where at Blackheath the first golf club south of the Scottish border was established in the early seventeenth century. When Elizabeth I died in 1603 leaving no heirs, James VI of Scotland, the next in line of succession, moved the Scottish court to

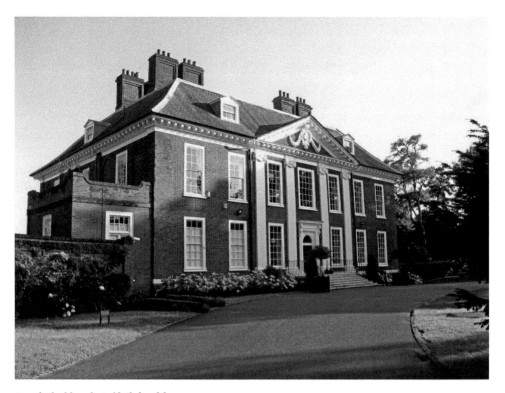

Royal Blackheath Golf Club, Eltham.

the royal palace at Greenwich. As golf had been played in Scotland during the preceding 150 years, the king and his entourage were all experienced golfers and often journeyed up to the heath to play a round or two. It is documented that the Prince of Wales, Henry Frederick, son of James VI of Scotland and I of England, played golf on Blackheath in 1606, around the time Blackheath Golf Club was established. Although there is no written evidence of the formation date, in golfing circles Royal Blackheath is considered to be the oldest golf club outside of Scotland. The club's first meeting place was the Chocolate House, close to the course, before moving to the Green Man public house, which once stood at the top of Blackheath Hill. Since 1875 the members played annually for the original and oldest Calcutta Cup, a silver trophy given as a gift by the Royal Calcutta Golf Club in return for a medal presented by the Royal Blackheath Golf Club. The cup was made from melted-down silver rupees, reputedly from the same batch as those used in making the Rugby Union Calcutta Cup, competed for by England and Scotland. At first the Blackheath course only had five holes, extended to seven in 1844, then when eighteen holes became the standard number Royal Blackheath, unable to expand because the course was bounded by the park and the main road from London to Kent, relocated to Eltham golf course in 1923 close to Eltham Palace. Sharing the Green Man as their headquarters were a group of oarsmen, cricketers, gymnasts and sportsmen, moving from Peckham to Blackheath in 1878. The club changed its name from Peckham Hare and Hounds to the Blackheath Harriers, and by 1888 membership had soared to in excess

of 200. The club had long ties with the Territorial Army, an active volunteer reserve force, the Boer War and then the First World War placing considerable demands on the club both in terms of members volunteering for service and pressures put on those remaining to keep the club running. The Blackheath Harriers later moved to West Wickham for cross-country running and to Catford Bridge for track meetings. In 1937, Blackheath Harrier Sydney Wooderson, known as the Mighty Atom due to his small stature and light weight, became legendary in the world of athletics when setting a world record by running the mile in 4.64 minutes. In recent history, Greenwich has been the starting point for one of the largest mass participation running races in the world, the London Marathon, where runners set off for the first time from Greenwich Park and Blackheath in 1981 on a course of just over 26 miles, taking in many iconic and historic landmarks of Greenwich before heading for the docklands and onwards to finish in central London. As the London Marathon grew in size, with more participants taking place, fun runners started competing along with Olympic and Paralympian champions. Greenwich became the venue for several Olympic and Paralympic sports in 2012, including shooting, archery and equestrian events, sporting activities associated with Greenwich for over 600 years.

DID YOU KNOW?

The most famous golf painting in the world, the portrait of Henry Callender, Captain General of the Blackheath Golf Club, was sold by the club in 2015 for £722,500 to raise money to buy the course and clubhouse freehold.

2012 Olympics, Greenwich.

8. River Trading

The Royal Borough of Greenwich has long and ancient associations with maritime trades and shipbuilding. In times past, the riverfront of Greenwich would have been crowded with boats, barges and ships of various size, loading and offloading cargo at wharfs and jetties, goods moved to and from shore by tall cranes and derricks, while other produce and commodities were carried around the river by lighters steered with expertise by Thames Lightermen. Vessels of all types had once been built and launched from the south bank of the Thames since the early medieval period, where archaeological evidence suggests many small river craft were constructed specifically as a means of crossing from one side of the Thames to the other up until the first permanent ferry service was established between the Isle of Dogs and Greenwich during the mid-1400s. Since the Middle Ages, Greenwich had a thriving fishing industry, the boats, most likely built at Greenwich yards, sailed out from Greenwich Dock down the Thames heading out into the North Sea. The Greenwich fishing industry prospered up until the expansion of the steam railways, when fresh fish could be transported quickly from ports in the north to London by freight train, forcing the Greenwich fishermen and their families to sail out from the Thames for the last time, relocating to the fishing towns on the north-east coast of England. At West Greenwich, across the mouth of the tidal River Ravensbourne, Henry VII had his ships repaired at yards that later became Deptford Royal Dockyard.

DID YOU KNOW?

Woolwich-built frigate HMS *Dolphin*, one of the ships in Admiral Byng's fleet at the Battle of Minorca, became the first ship to circumnavigate the globe twice. The first trip, between 1764 and 1766, was the fastest ever circumnavigation to have been completed, the second, between 1766 and 1768, became famous for the discovery of Tahiti.

The King's Yard was taken over by Henry VIII in 1513 to carry on his late father's work creating a powerful English navy. Henry also established a royal dockyard at Woolwich in the same year, where the Carrick warship *Henry Grace à Dieu*, known as the *Great Harry*, had been commissioned to be built at Gun Wharf, Old Woolwich in 1512. Between the sixteenth century and nineteenth century, the dockyards of Woolwich and Deptford built and launched over 600 vessels of varying rate, the ships being deployed in a multitude of roles and engaging in numerous actions and battles around the globe.

Deptford Royal Victoria Victualling Yard.

After building ships for more than 350 years, Deptford Royal Dockyard closed in 1869 and was converted into a large cattle market. A majority of the site was then built upon after suffering bomb damage during the Second World War. Among the residential and industrial buildings it is still possible to discover the few remaining remnants from the time when West Greenwich, was a thriving shipbuilding industry. The eighteenth-century Master Shipwright's House, Victualling Yard, riverside buildings and gatehouse colonnade, all now private dwellings, have survived, as have the main Victualling Yard gates and riverside dockyard gates and steps. Recent excavations carried out prior to further redevelopment of the old dockyard site uncovered the foundations of the Tudor store, dock basins and slipways, and at Conyers Wharf, the Grade II-listed Victorian shipbuilding shed, known as the Olympic Building, is still standing on land destined to become modern apartments and commercial buildings.

A large magnificent Tudor manor house, once located adjacent to the dockyard and partially rebuilt during the late 1800s, was unexplainably demolished shortly after the Second World War, although it has been suggested the house may have suffered damaged during air raids. Lived in by Sir John Evelyn, writer, gardener and social diarist, Peter the Great was entertained at his house while the tzar was studying shipbuilding at Deptford. The remains of the foundations lying below a small public park and an area of Conyers Wharf came under threat from developers proposing to build on the site until a group of residents campaigned to have the remains preserved as a place of national

Olympia Building
slipway cover.

Crowley House,
also known as
the Old Palace.

importance, the World Monument Fund placing Deptford Dockyard and Sayes Court on a watch list of endangered heritage sites, the Council of British Archaeology also joining the campaign to have the location protected. In 1704, Sir Ambrose Crowley, a wealthy Newcastle iron master, whose foundry made iron anchors for ships and shackles and chains for the slave trade, built Crowley Warehouse and Crowley Wharf when acquiring a large elegant riverside mansion next to Trinity Hospital on Highbridge Wharf. Renamed Crowley House, the property had once belonged to Andrew Cogan a member of the East India Company before the royalist was forced to escape to Holland towards the end of the English Civil War, leaving the house partly completed. Erected on or close to the site of the old Greenwich Court House, the property was believed to have been built towards the late Elizabethan period, known to the locals as the old palace.

Crowley House came into the possession of the Millington's, where the family resided for around fifty years. Crowley warehouse was demolished in 1853, and when a buyer

for Crowley House could not be found, it was cleared and dismantled, the materials sold as salvage. The grounds were used as a horse-drawn tram depot before Greenwich Power Station was erected on the site during the early 1900s, built to run London's electrified tram network. As electrified trams were phased out, Greenwich Power Station became the backup power source for London's Underground system. On the power station's high brick-built boundary wall, facing the river, a three-dimensional art installation, a *Thames Tale*, created by artist Amanda Hinge, mounted into the brickwork during the millennium year, depicts the adventures of a young Thames mudlark. Another modern riverside artwork, a giant anchor and chain designed and made by sculptor Wendy Taylor, stands at Anchor Iron Wharf opposite the Cutty Sark public house, and is dedicated to Crowley's Iron Anchors and the riverside scrap metal merchants. Towards the east of the row of houses at the junction of Ballast Quay and Lovell's Wharf is the detached Harbour Master's Office, built in 1855 on the site of a former Greenwich fisherman's dwelling, Thames Cottage. The Greenwich harbour master controlled the movement of colliers bringing coal in from the north-east of England to London. Along the riverfront from Ballast Quay to the wide expanse of Greenwich Marsh, the whole area of East Greenwich became heavily industrialised throughout the late nineteenth century and early twentieth century, a majority of the industries associated with the coal trade and coal byproducts.

Art installation *A Thames Tale*.

During the building of a residential development at Lovell's Wharf in 2008, the remains of a twelfth-century tidal mill was discovered in the mud, believed to have been the first industrial structure built on the marsh, and the earliest tidal mill discovered, to date, in London. Before the discovery of the mill, an Elizabethan watchtower, converted for use as a Government Powder Magazine in 1694, was believed to have been the first major building on the marsh. Because of the concerns Greenwich residents had about possible explosions, the magazine was transferred to Purfleet in the late eighteenth century. Up until the mid-nineteenth century, a majority of commercial shipbuilding south of the river had taken place at Deptford yards, adjacent to the Royal Dockyard. However, in 1864 American businessman Nathan Thompson established the National Company for Boat Building by Machinery on the marsh at Bay Wharf where a break in the river wall, known as Horseshoe Breach, formed a natural slipway. Thompson's idea was to mass produce iron-built vessels on a production line, and although this new evolutionary method of constructing rivercraft was a success, the venture failed commercially as there was a lack of demand for the volume of craft produced. The yard was then taken over by Maudslay Son and Field, an engineering company expanding into the building of large ships. The first to be launched from Greenwich Marsh in October 1865 was the steam collier *Lady Derby*, named after wife of Prime Minister Edward Smith-Stanley, 14th Earl of Derby.

DID YOU KNOW?

In the reign of James I the first ever submarine seen in England, designed by Cornelius Drebby under patronage of the king, made an appearance at Greenwich, the submersible powered by oars, travelling from Westminster to Greenwich and back. The king was the first monarch to travel underwater when taken on a test dive in the Thames by Drebby.

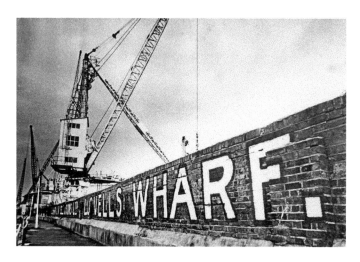

Lovell's Wharf.

The owner of a fleet of sailing vessels, Scotsman John 'White Hat' Willis – his nickname acquired through his habit of always wearing a white top hat when ashore – commissioned Maudslay Son and Field to build two tea clippers along the lines of the pride of his fleet, the Clyde-built *Cutty Sark*. To keep the production costs low in comparison to the money spent to build the *Cutty Sark*, a composite ship where an iron structure was clad with wood and the hull sheathed in copper, Willis wanted both new clippers to be built in iron. Maudslay Son and Field were relatively inexperienced in iron shipbuilding and after the *Blackadder* was launched in February 1870, the clipper almost came to grief on its maiden voyage bound for Shanghai, when the metal mainmast and mizzenmast collapsed. The second clipper, *Hallowe'en*, fared better after its launch in June 1870, although both ships had a number of technical complications and sailing mishaps during their early voyages. It was said that the *Hallowe'en* was the better ship to sail, rivalling the *Cutty Sark* for speed and beating the time of the famous clipper *Thermopylae* when returning from the China Sea. After many profitable, but long hazardous voyages, both the *Hallowe'en* and the *Blackadder* were lost at sea. Their sister ship, the *Cutty Sark*, fared better, where after several changes of ownership, the clipper was placed in dry dock at Greenwich in 1954. Although vessels are no longer built and launched at Bay Wharf, Thamescraft Dry Docking Service, now occupying the site, repair and maintain workboats, pleasure boats and various types of naval craft.

In 1868 shipbuilders Alfred Lewis and John Stockwell, whose main yard was at Bow Creek on the opposite side of the river, established a yard at Ordnance Wharf on the eastern bank of Greenwich Marsh. The work undertaken at Greenwich was mostly repair work, although steamships were believed to have been built for foreign owners at the yard, one of which, the *Bulli*, was an iron-built steam-powered three-mast topsail schooner.

Blackadder, a Greenwich-built clipper.

Above: Enderby Wharf cable-winding gear.

Left: Enderby Wharf Ferry steps.

Many of the Lewis and Stockwell steamships used engines supplied by Greenwich-based John Penn & Son, one of the country's leading marine engineers. On Greenwich Marsh, when building and launching large ships was nearing an end, independent boatyards building smaller river craft diversified into constructing Thames barges, vessels used to transport a variety of cargo back and forth along the river – grain, flour, bricks, timber and much of London's refuse. The most prominent local barge builders at the time were Augustus Edmonds, James Piper, Horace Shrubsall, James West and Fredrick Hughes. One important family-run business moving to the marsh during the mid-1800s to expand their shipping, whaling and sealing activities were the Enderby's, Herman Melville mentioning the Enderby's in his novel *Moby Dick*. The family purchased an existing rope works, close to where the Elizabethan gunpowder magazine was sited, constructing a new rope and canvas workshop and private family residence built on the river's edge, Enderby House. The site was later sold to a company developing and producing telegraph cables, where the first transatlantic subsea telegraph cable laid from Britain to America was manufactured. Although modernised industrial units producing subsea communication equipment are still in operation at the site, the river frontage was sold for redevelopment as residential properties and a proposed cruise liner terminal, the mid-nineteenth-century Grade II-listed Enderby House, along with the jetty and winding gear machinery, once used to transfer cable onto cable laying ships, are the only surviving reminders of the important role the telegraph works on Greenwich Marsh played in the development of global communications. Between two jetties at Enderby Wharf, a long flight of splendidly sculptured steps are revealed with the falling level of the tide. The steps, made of hard marine wood with designs carved by sculptor Richard Lawrence depicting the industrial history of Greenwich Marsh, were installed in 2001, on the original steps and landing stage used by boats to ferry workers between the cable works and the cable-laying ships moored in deep water. Although Greenwich Marsh had never been heavily populated, a majority of the land taken up by industrial and manufacturing works, alongside two huge gasometers built between 1881 and 1886, at the time the largest of their kind in the world, hundreds of residents were relocated from their dwellings, which were then demolished to make way for constructing Blackwall Tunnel in 1892. On completion, Blackwall Tunnel became the longest tunnel ever built under a river, regarded at the time as the twenty-first wonder of the world.

As the tunnel was used mostly by pedestrians, cyclists and horse-drawn vehicles transporting goods both north and south of the river, the bore was constructed with several sharp bends to prevent horses from bolting as soon they glimpsed daylight at the opposite tunnel entrance. The original plans included classical-style arches at each end, however, these were superseded by splendidly designed rectangular gatehouses, constructed in contrasting red and light-brown sandstone, with an octagonal turret in each four corners of the roof. The gatehouses included lodgings for a superintendent and a caretaker. The northern gatehouse was demolished when the second tunnel was built during the 1960s. The Greenwich gatehouse, however, survived, the impressive structure now surrounded by numerous obtrusive road signs, signal lights, lampposts and grey metal crash barriers. During a period when both shipbuilding and armaments production at Woolwich had rapidly expanded between the late sixteenth century and

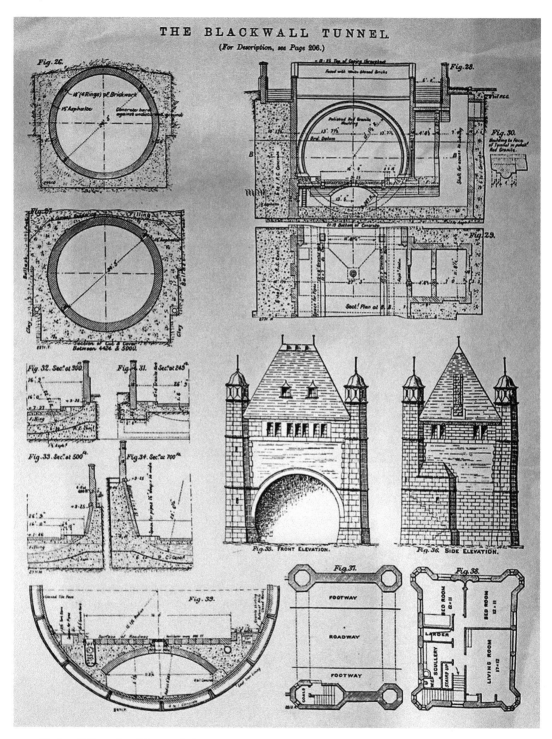

Blackwall Tunnel architectural plans.

Woolwich Ferry paddle steamer *Hutton.*

DID YOU KNOW?
Naval sailing vessels passing Greenwich Palace always fired a canon salute, a tradition that was discontinued after a ship fired a shotted gun by accident, the cannon ball smashing through the window of Queen Elizabeth's private apartment.

early nineteenth century to support British commercial and national interests overseas, various associated workshops and industries were established at both the shipyard and armaments site, including a bronze foundry, gun yard, ordinance yard, gunpowder works, various laboratories and a ropeyard dating to the Elizabethan period, which at the time was the longest in the world, at over 1,000 feet in length. In 1665, Prince Rupert Fort was constructed to house sixty guns as a defence against the possibility of a Dutch invasion fleet sailing upriver during the Anglo-Dutch war. Although a public ferry service had operated at Old Woolwich since the fourteenth century, the opening of the Royal Dockyard and Royal Arsenal brought an increase in traffic across the Thames, the armed services establishing a ferry in 1810 for transporting workers, supplies and troops. The following year by Act of Parliament, a commercial ferry service began operation that continued up until the mid-1800s when the ferry was taken over by a succession

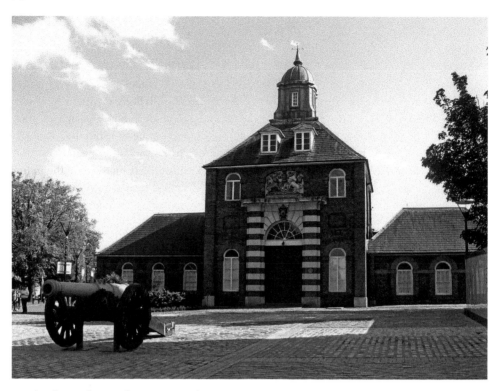

Woolwich Royal Arsenal Bronze Foundry.

of ferry operators. In 1889 the Metropolitan Board of Works funded a free ferry service running between Old Woolwich to North Woolwich, financing the construction of ferry terminals either side of the river and the building of two paddle steamers, the *Gordon*, named after Woolwich-born General Gordon, killed at Khartoum, and the *Duncan*, named after Colonel Francis Duncan, author of *The History of the Royal Artillery*. A third ferry, commissioned later, was given the name the *Hutton* after Charles Hutton, professor of mathematics at the Woolwich Academy. Today, the Woolwich ferry service runs three diesel-powered vessels, one kept in reserve, where vehicles and foot passengers are able to cross the river for free. By the late nineteenth century, the Royal Arsenal reduced its workforce around the same time as the Royal Dockyard was closing down, which left a majority of the large working population of Woolwich facing unemployment, many deciding to seek their fortunes elsewhere, taking up an opportunity offered to immigrate to Canada. After closure of the dockyard, the War Office retained much of the site for use as storage facilities until it was redeveloped as council housing during the late 1900s, only the dockyards main gates, the clockhouse offices, dock basins and mast ponds being retained. Two of the basins were filled with fresh water for use as fishing ponds. After the scaling down of munitions manufacturing at the Royal Arsenal during the mid-1900s, areas of the site surplus to requirement were disposed of, and by 1994, the Woolwich Arsenal closed altogether. Destined to become another large housing development, a majority of the principal historic buildings were retained and refurbished for use as

accommodation, bars, restaurants, a heritage centre and museum. Today you can travel from Greenwich Pier on a fast Thames Clipper river bus west toward Deptford or east to Woolwich, and discover where England's Tudor navy was born, famous ships were built and launched, and from where Britain's seaborne and land forces were armed during 500 years of military history. The landscape of the Thames South Bank at Greenwich, once dominated by the Royal Naval College, is now made up of modern high-rise apartments, offices and hotels, replacing the industrial buildings, commercial warehouses, wharves and tall cranes once occupying the riverfront of Greenwich. Visitors today heading for the most well-known historic attractions and landmarks are most likely unaware of the many secret places of Greenwich from years gone by.

Greenwich: Maritime World Heritage Site and Centre of the World.

Acknowledgements

I should like to thank all those who have contributed to *Secret Greenwich* by supplying images, memories and information used in this publication, and if for any reason I have not accredited people or organisations as necessary, I should like to apologise for any oversight. I should also like to express my thanks to the following list of organisations and people without whose help I would not have been able to produce this book:

Greenwich Heritage Centre, Caird Library & Archive National Maritime Museum, Old Royal Navy College, Royal Parks, Royal Blackheath Golf Club, British Library, Creativecommons.org, Lloyd Rich, Elizabeth Ramzan, Tim Hegarty and the many postcard fairs and antiquarian shops visited to locate archive images.